PRINT'S BEST LOGOS & SYMBOLS 5

Manufactured in
Hong Kong.

PRINT's Best
Logos & Symbols 5
Library of Congress
Catalog Card Number
89-091068
ISBN 1-883915-06-6

RC Publications
**President and
Publisher:**
Howard Cadel
**Vice President and
Editor:**
Martin Fox
Creative Director:
Andrew Kner
Project Manager:
Katherine Nelson
Book Designer:
Michele L. Trombley
**Administrative
Assistant:**
Robert Treadway III

Writer
Andrew Day

Art Director
Andrew Kner

Project Manager
Katherine Nelson

Book Designer
Michele L. Trombley

Published by
RC Publications, Inc.
New York, NY

Winning Designs from
Print *Magazine's*
National Design Competition

PRINT'S BEST

LOGOS

and

SYMBOLS

5

79

NONPROFIT
ORGANIZATIONS &
INSTITUTIONS

101

RESTAURANTS & RETAIL

125

EVENTS

139

SERVICES

INTRODUCTION

More and more, "branding" is the hot buzzword among graphic designers working in marketing and advertising. This is nowhere more apparent than in the way the designers featured here talk about their work. Very few of them set out simply to "design a logo." In the main, they describe their efforts as "creating an identity" for a product, service, company, organization, or event.

What does this all mean? In practical terms, identity-creation involves a marketing campaign that introduces or broadens the appeal of a product or service, usually among the members of a specific target group. Designing a logo is rarely the only aspect of such an effort.

Are the references to "branding" merely meaningless marketing-speak? Not really. Many times designers use convenient figures of speech to show clients that they understand the way businesses work, or at least think. But the rise of a new buzzword is indicative of something deeper. In this case, there's been a shift to a new conception of marketing, and a change in the way designers and clients alike approach logos and symbols of all sorts.

At the risk of sinking deeper into advertising wonk-talk, let's just say a logo or a symbol not only represents a product, but is integral in building a relationship with customers. By approaching the design of a logo as part of an overall identity effort, designers and clients convince their target audience that they are linked by something deeper and more permanent than the ephemeral decision to buy or take part. A purchase is made, not on the basis of a coldly rational assessment of a product's particular qualities, but rather because it's as familiar and friendly as a family member or trusted colleague. The assumption is that a reservoir of loyalty can be built up so that when customers choose a particular product or service, they will continue to do so again and again.

Identity, then, is not a chance term. But the old ways of creating a "product image" are now unsuited to efforts to appeal to today's savvy customers and clients. The designers of the logos featured in this volume face greater challenges than their predecessors in getting their message out—media saturation and increased competition everywhere. Also significant is the increasing personalization of much of American life—with more and more people treating decisions about what to buy as decisions about who to be. In this atmosphere, advertising must ensure that audiences will make associations that are less comparative or logical, and more personal and emotional.

Creating logos that work demands conceptually and visually innovative solutions. How do today's designers meet this challenge? The clearest way to understand their efforts is to look at the best work being done; we recommend that you start by simply turning the page. —*Andrew Day*

GRAPHIC DESIGN FIRMS

Do graphic designers save the best logos for themselves, or is the prospect of creating an identity for their own firms exceptionally inspirational? None of those whose work is featured in this section admits to either proposition, but the uniformly high quality of these logos indicates that both may well be true to some degree. Perhaps it's the immediacy of the task at hand—selling not someone else's product, but one's own company. Or maybe it's the fact that so many of these studios are one-person operations. Creating logos for them is an intensely personal endeavor—and also the client always says "yes" to the designer's favorite idea!

While many of these logos are strong from both a visual and a conceptual standpoint, they aren't as daring as one might expect—after all, designers are well aware that potential clients will often see a logo before having the chance to examine any other examples of a firm's work. But in creating marks that will ensure that those first impressions are good ones, these designers are concerned not with being flashy, but with giving a sense of the work they can be expected to turn out on a regular basis, as well with conveying something of their firm's character and general approach to design.

Davidson wanted his clients to know that he is determined to collect on all invoices. However, he didn't want to offend them and risk losing their patronage. Intending these symbols to be humorous, Davidson relates that several of his customers told him they fear the "red dog" mark on overdue invoices—truly the sign of an effective design! He developed the designs in Adobe Photoshop and Streamline, as well as Aldus FreeHand.

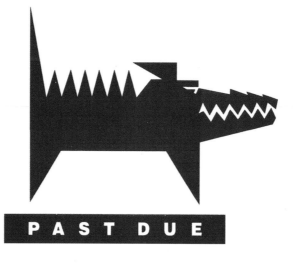

Design Firm:
DOGSTAR,
Birmingham, AL
**Art Director/Designer/
Illustrator:**
Rodney Davidson

THANKS!

TIDBIT

KILL FEE

KATHY MOHL

The logo for this one-person firm has a "personal touch"—its central image is Mohl's own thumbprint, which she scanned and reworked (by adding a fish tail) using Aldus FreeHand. Her design suggests a highly personal approach that is fresh and informal. It avoids portraying her as a "cold corporate type."

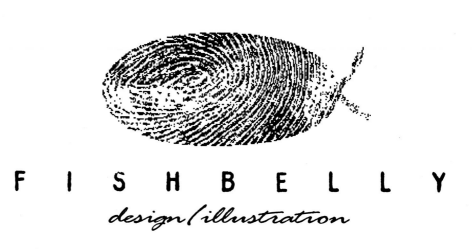

Design Firm:
Fishbelly Design/
Illustration,
Twinsburg, OH
Designer:
Kathy Mohl

Adams wanted his logo to be immediately recognizable and give a distinctive identity to his new firm—whose name virtually mandated a fish image. Using Adobe Photoshop and QuarkXPress, Adams rendered the fish in solid black, making it not only striking in appearance, but also easily and clearly reproducible, on business cards, company stationery, and the firm's Web site.

B I G F I S H D E S I G N

Design Firm:
Big Fish Design,
Germantown, MD
Art Director/Designer/
Illustrator:
Brian Adams

This logo, which replaced an earlier one, reflects the designer's personality and suggests that this husband-and-wife-run firm produces exciting, volatile designs. Additionally, it is easily reproducible on both office and promotional materials. Payne used an old wooden stamp to render a bold uppercase *P* on paper. He then added stylized "flames"—a reference to hot-rod cars, one of his hobbies—by hand. He photocopied the result of his efforts, then scanned it and cleaned it up using Adobe Streamline and Aldus Freehand.

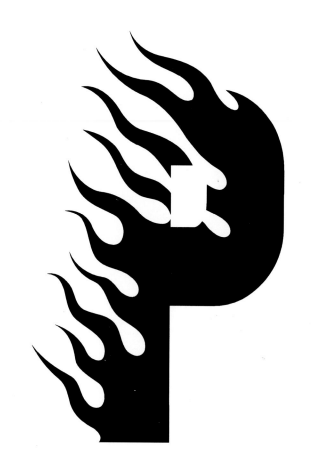

Design Firm:
Pro Payne Graphics,
Mechanicsville, VA
Designer:
Phillip Payne

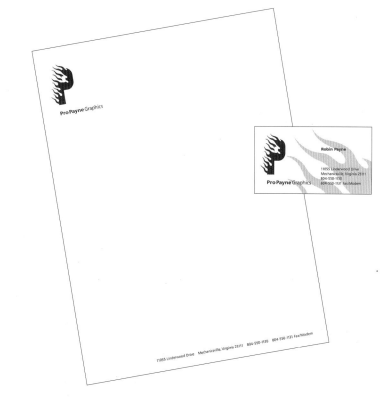

Design Firm:
Flaherty Robinson Design,
Barrington, RI
Designers:
Gayle Flaherty,
Scott Robinson

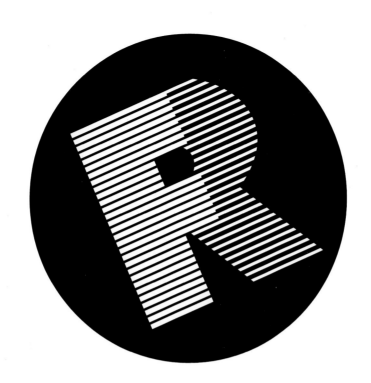

Flaherty and Robinson are not only business partners, but husband-and-wife as well. Combining the first letters of their names expresses the collaborative nature of their relationship. Starting with a rough hand-sketch, they used Adobe Illustrator to complete the logo and then rendered it in two colors for offset reproduction on the firm's stationery, which was laid out in QuarkXPress.

FLAHERTY ROBINSON DESIGN

Green chose the familiar image of Rosie the Riveter to serve as the new symbol of her firm. She'd been planning to do this for years—her old logotype was too conservative and unsuited for use on the World Wide Web, she relates, while Rosie conveys a sense of her own style and personality. Working from a refrigerator magnet, Green made a series of ink line drawings that she then scanned and reworked using Adobe Photoshop. She set the type in Adobe Illustrator. Using a Canon color copier/ printer, she reproduces the logo on letters, resumes, and sample sheets as she needs them.

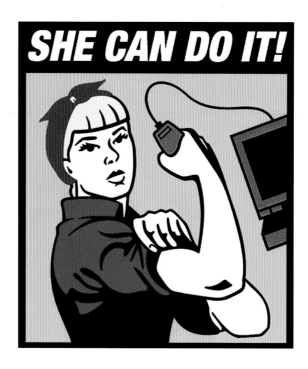

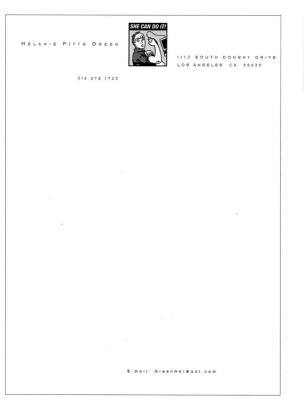

Design Firm:
Melanie Pitts Green,
Los Angeles, CA
Designer:
Melanie Pitts Green

This logo provides a strong visual identity for Horace Hume Design and, moreover, indicates to potential clients that Hume is ready to work and take full personal responsibility for satisfying them. Originally, the logo featured a drop shadow forming a second *H*; Hume eliminated it, feeling it weakened the design. He used Adobe Illustrator to craft the image, which was then transferred onto various materials using 2-color offset, silkscreening, and a laser printer.

Design Firm:
Horace Hume Design,
Atlanta, GA
Art Director/Designer:
Horace Hume

Created to establish this new firm's identity to potential clients, its logo suggests that Inkhaus is both rooted in tradition and progressive in its approach to design—the inkwell symbolizes the former, while the latter is conveyed by the sleek, stark look of both the logotype banner and the central image. Rendered in simple black-and-white, the mark both stands out visually and is easily reproducible. A hand-executed illustration serves as the basis for the mark, with QuarkXPress used to prepare it for reproduction.

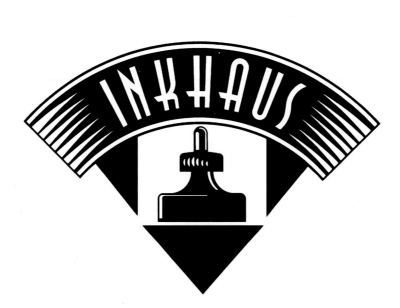

Design Firm:
Inkhaus Design,
Red Bank, NJ
Art Director:
Daniel Schroll
Designer:
David DeSantis

Design Firm:
Annette Bauman Design,
Seattle, WA
Designer:
Annette Bauman

D E S I G N

Bauman describes her specialty as creating corporate identities—something she did for her own firm by replacing its former typographic logo with this new one based on a human figure that's "whimsical but not cute." The design reflects something of her own personality, but also suggests her facility with both digital and traditional design techniques—the clean, crisp lines of the logotype and the figure's body and limbs are a reference to the former, while its ink-splat head alludes to the latter. Bauman used Macromedia FreeHand to devise this mark, which was then offset-printed onto business cards and laser-printed onto various company promotional materials.

The name Cheddarhead refers to the designer's own Wisconsin origins and has no southwestern connotations—which helps his firm stand out among the local competition. Kohlman began with a hand-executed sketch, which he then scanned and reworked in Adobe Illustrator. He then used QuarkXPress to do layout work for business cards and the firm's stationery.

Design Firm:
Cheddarhead Design,
Albuquerque, NM
Designer/Illustrator:
Gary Kohlman

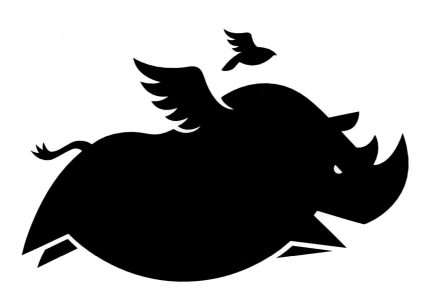

Choosing a black rhino for this logo was easy, but rendering it was more difficult. The designers rejected both overly realistic and abstract designs before settling on this stylized depiction of a rhino on the run, which they created in Adobe Illustrator for offset printing onto the firm's stationery and other materials. This logo represents an updated version of the firm's previous one, which also included the image of a rhino, albeit a much less modern-looking one.

BLACK RHINO GRAPHICS

Design Firm:
Black Rhino Graphics,
Dallas, TX
**Art Directors/Designers/
Illustrators:**
Kristine Murphy,
Brandon Murphy

A drawing jester reminds potential clients (ad agencies, design studios, corporations, and publishers) that this firm's specialty is producing humorous designs and illustrations. Using a library picture of a medieval jester as his starting point, Peters put the final logo together using Adobe Photoshop and Streamline. He rendered the image in straight black with a fair amount of white space so that, despite the high level of detail, it would be easily reproducible on materials of various sorts.

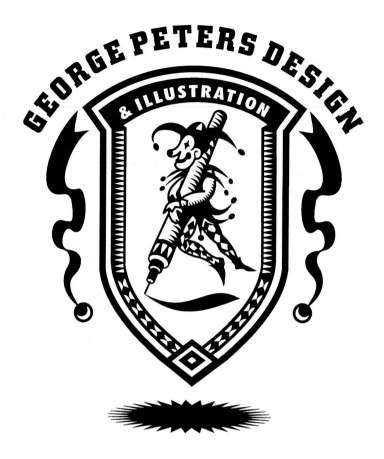

Design Firm:
George Peters Design and Illustration, Minneapolis, MN
Art Director/Designer/ Illustrator:
George Peters

Remember me, Phillips reasoned, and you'll remember my company—so he used a highly stylized representation of his own head as the basis for this logo. In conveying a sense of his own personality, he also gave the image a friendly, whimsical appearance by using curvilinear, thick lines, dropping out his own facial features, and topping his head with a mop of floppy blond hair. Working from pencil sketches, Phillips used CorelDraw to create the final design.

Design Firm:
Mike Phillips,
Ogden, UT
Art Director/Designer/Illustrator:
Mike Phillips

Clients, vendors, and other designers have responded favorably to this logo, in which a rebus "spells out" the firm's name. Originally, its centerpiece was an image of ivy leaves, but the designers preferred the more playful approach reflected here. QuarkXPress and Adobe Illustrator were used to create the logo, which was then offset-printed onto company stationery.

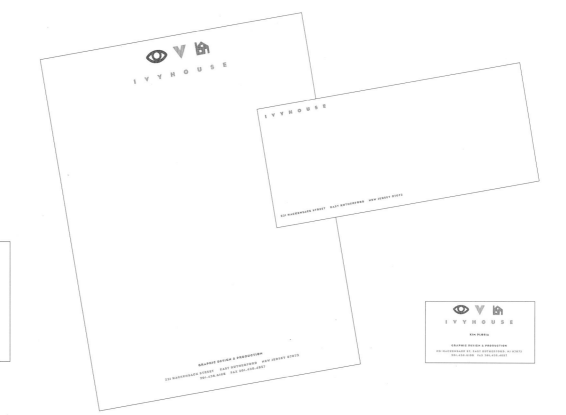

Design Firm:
Ivy House Graphic
Design & Production,
East Rutherford, NJ
Art Director:
Kim Plosia
Designer:
Robin Malik

The firm's function is conveyed in a highly stylized fashion in this new logo for Peter Hollingsworth & Associates. The central image of an artist at work suggests the firm's commitment to considered, carefully crafted designs, and includes an exclamation point, to evoke excitement. Working from an initial hand sketch, Wammack created the final logo in Aldus FreeHand, layering component elements until they formed a cohesive whole. Offset lithography was used to reproduce it on firm stationery and various promotional materials.

Design Firm:
Peter Hollingsworth &
Associates,
Winston-Salem, NC
Designer:
Steven John Wammack

PETER HOLLINGSWORTH & ASSOCIATES

In creating her firm's holiday greeting cards, Chu wanted a simple, striking, and original symbol to convey the spirit of the season. She tried various design concepts before hitting on this one, a visual pun in which the letters in the phrase "ho ho ho" form the head of a reindeer. She created the logo in Adobe Illustrator for 2-color offset printing onto the holiday cards. Seeking to save on reproduction costs, she rendered the design in red and black—the same colors used on her firm's business and note cards—then had all the items printed together on the same parent sheet.

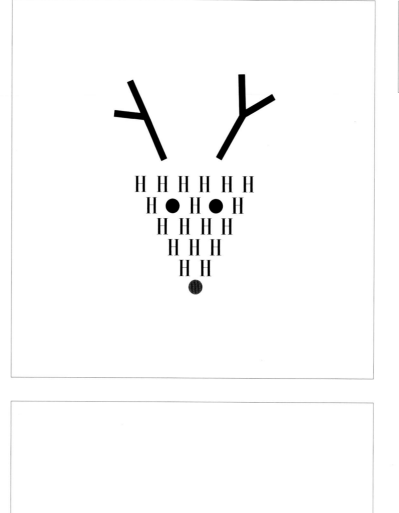

Design Firm:
Elaine Chu
Graphic Design,
Oakland, CA
Art Director/Designer:
Elaine Chu

ENTERTAINMENT & LEISURE

Here is a set of designs that must have been nothing if not pure fun to create—after all, if drawing up logos for entertainment and leisure companies isn't enjoyable, what is? The way Art Chantry, Seattle's grunge design king, describes his work, for example, it doesn't even sound like work. Found an old matchbook? Photocopy it, touch it up a bit, and your next project is done! And as for Rodd Whitney's logo for the Fish Heads—one wouldn't call it art, maybe, but one *would* call it first-rate design, fresh and fun, and entirely appropriate to the task at hand.

Of course, some of these designers take a more formal approach to such assignments. Witness Miyoung Kim's sleek microphone for Guest 2539 Karaoke Bar. Another example is USA Network's mark for the film *Death Benefit*—it's exhausting just reading through the list of project goals, and retracing the steps Lisa Orange took in meeting them. But in the end, the *Death Benefit* logo works just as well as the one Chantry created for Moe's Mo' Roc'n Café, appealing, perhaps, to a different market segment, but creating the same sense of gloom and foreboding. (Whether one can say that the film is as successful as the club is another matter entirely.) Inventive and informal, logos devised for entertainment companies are some of the coolest in this volume.

Music

With the exception of the logo Miyoung Kim created for New York's Guest 2539 Karaoke Bar—its clean lines and spare layout achieve visual elegance and restraint—these marks are among the most informal you're likely to see. Art Chantry's work in particular typifies an approach common among designers who work in music and entertainment. His style conveys a sense of fun and youthful exuberance: his designs look as if they were dashed off as an afterthought. The sophistication of the logos in this section lies in their "studied sloppiness," an effect heightened by their designers' shrewd use of "low-culture" sources—the childlike drawing at the center of the Fish Heads logo, the altered NASCAR logo which sells the rock group Southern Culture on the Skids, and the stripper-in-a-martini-glass for the music ensemble the Mono Men are just a few examples.

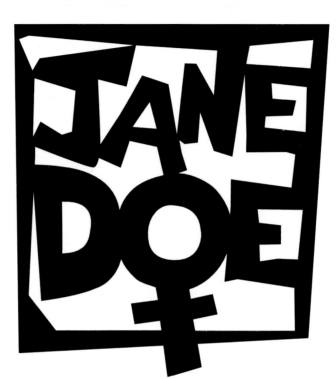

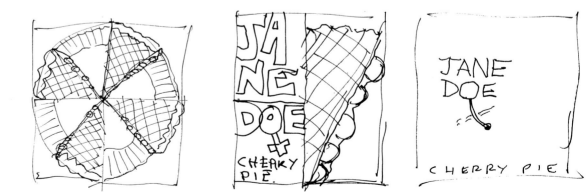

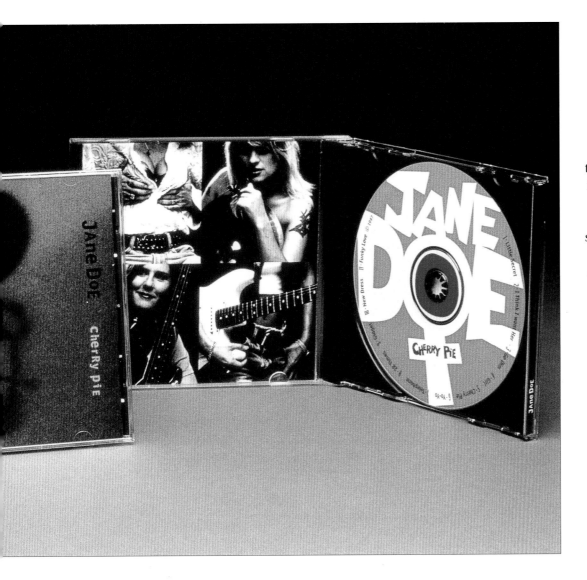

The members of Jane Doe, a self-described "all-girl rock band," wanted a logo that would be "strong and graphic," as well as clearly reproducible in newsprint and on stickers and photo-copied fliers. In addition, they wanted it to "say female" in some obvious way. Aldridge presented them with several thumbnail sketches, then scanned the one they selected and fleshed it out using Adobe Illustrator. For the CD cover, the band's name was typeset, but its "logo-ness" was maintained by turning the letter *O* into the easily recognizable symbol for female.

Design Firm:
Sibley/Peteet Design, Dallas, TX
Designer/Illustrator:
Donna Aldridge
Photographer (CD cover):
Manny Rodriguez
Photomanipulation (CD cover):
Brent McMahan

Whitney freely admits that he originally designed this logo (a drawing he scanned and touched up in Adobe Illustrator) for a fish and chips restaurant, which rejected it. The Fish Heads, an alternative rock band who wanted to convey what Whitney calls the "strange lyrical content and humorous style" of their songs, loved it at first sight, and have used it ever since.

Design Firm:
Smit Ghormley Lofgreen
Design, Phoenix, AZ
Art Director:
Rodd Whitney
Designer:
Rodd Whitney

Designer:
Art Chantry, Seattle, WA

Chantry notes that because Estrus Records "goes through logos like you or I would go through socks," he takes a casual approach to designing them. For this one for a rock band, he photocopied the image from a matchbook he found on the floor of a bar, hand-lettering the band's name over the top of it. As for the logo's reflecting the essence of the group's music, Chantry points out that his main concern was to ensure that the design would be in properly poor taste—a goal he seems to have achieved quite nicely.

DAVE CRIDER/ESTRUS RECORDS

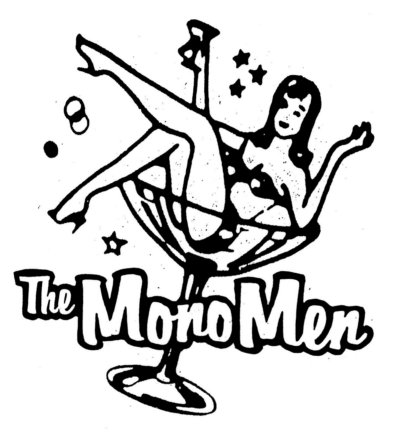

This hand-drawn logo for a rock band was designed to be reprinted on baseball caps and T-shirts sold at concerts. Chantry makes a visual play on the concept of "southern culture," reworking the emblem of the North American Stock Car Racing Association and substituting an acronymic version of the band's name for the more widely known shorthand "NASCAR."

Designer:
Art Chantry, Seattle, WA

SOUTHERN CULTURE ON THE SKIDS

Designer:
Art Chantry, Seattle, WA

Chantry's refreshingly informal approach to design excels in this logo, which was silkscreened onto coveralls and workshirts worn by stagehands at the Seattle rock club. Working in a recognizable comic-book style, he hand-drew the central wrecking-lot image as a sly reference to the stage crew's nickname—not, one hopes, to their style of work!

MOE'S MO' ROC'N CAFÉ

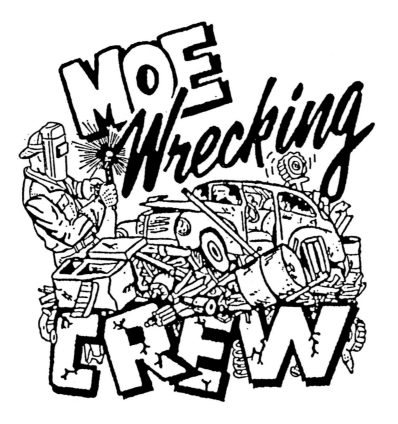

Kim's goal in devising this logo for a midtown Manhattan bar, which she did using Adobe Illustrator, was to to say "karaoke" in a way more "fun and inviting" than simply spelling it out— which led to her inspired idea of making a microphone the central image.

Design Firm:
m.y. design, Flushing, NY
Designer:
Miyoung Kim

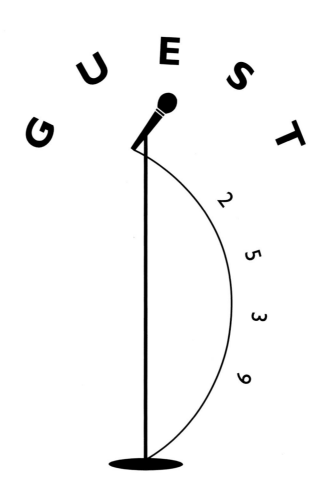

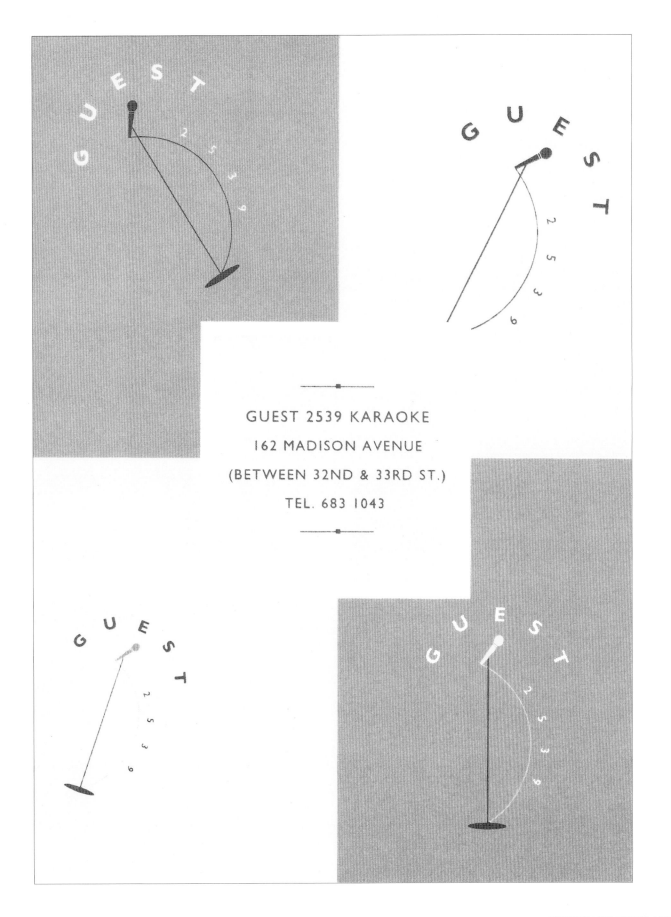

GUEST 2539 KARAOKE

162 MADISON AVENUE

(BETWEEN 32ND & 33RD ST.)

TEL. 683 1043

Broadcasting and Film

The business of the companies in this section is information, communication, and entertainment; they need to represent themselves professionally, but memorably as well. Many use humor and fantasy to promote a product identity or corporate attitude. Dread and foreboding pervade the distressed logo for the USA Network film Death Benefit. *Designer Frank Varela sets a door and two lighted windows in the outline of a black face, giving an ethereal dreaminess to the mark for the television series* Dream Living. *A lovable, haloed hound adds casual goofiness to Junebug Productions' mark, and* Sound & Spirit *combines seemingly disparate symbols, such as a pinwheel and a record, to spell out the name of the eclectic music radio program.*

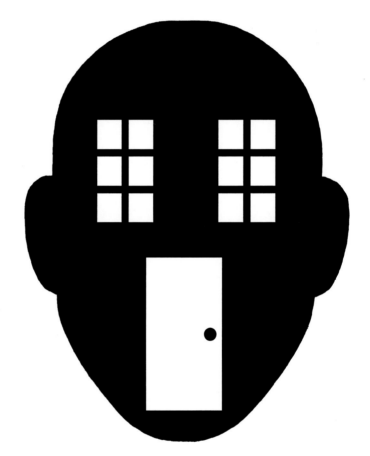

Design Firm:
Frank Varela Graphic
Design, Glendale, CA
Designer/Illustrator:
Frank Varela

In creating this logo for a cable television program showcasing celebrities' dream homes, Varela initially wanted to incorporate imagery taken from floor plans used by decorators. Focusing on the show's target audience—amateur and professional interior designers—he hit on the idea that "dream living" is above all a state of mind, a concept clearly reflected in his final design.

FILM GARDEN PRODUCTIONS

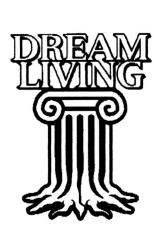

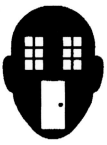

JUNEBUG PRODUCTIONS

Although this logo was meant to be used on presentation materials given to corporate clients, the owner of Junebug Productions—who named her film production company after her aging, overweight dog—wanted it to be free of any suggestion of seriousness or pretentiousness. The designers don't say if the haloed beast shown here was modeled on Junebug herself. After the pooch was drawn, the finished logo was prepared using Adobe Illustrator and Streamline.

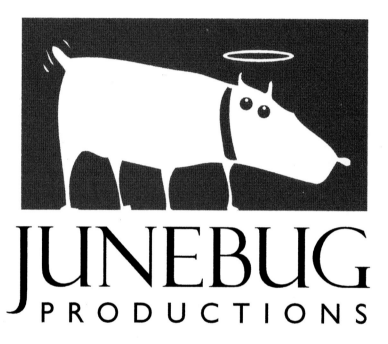

JUNEBUG
PRODUCTIONS

Design Firm:
Scott Brown Design,
Redwood City, CA
Art Directors:
Scott Brown, Kari Nevil
Designer:
Scott Brown
Illustrator:
Janice Wong

In putting together an initial promotional package for *Sound & Spirit*, a music program, Public Radio International (PRI) wanted a logo with an eclectic look that would reflect the mix of classical and international music featured on the show. The letters were scanned from various found images in Johnson's "closely guarded personal scrap collection," then reworked using Adobe Illustrator.

Design Firm:
Haley Johnson Design Company,
Minneapolis, MN
Designer:
Haley Johnson

STATION STORE

In developing a logo for use on promotional materials distributed by this producer of syndicated television shows, Kerr maximized the associative potential of the "store" metaphor. The grocery bag, he felt, was at once a "friendly" symbol and one that would appeal to television programming executives "shopping" for new shows for their stations. In drawing the logo itself, which he did using Aldus FreeHand, he was careful to ensure that the bag not be too "playful" or "whimsical" (which might suggest that his client was in some way less than professional). The result was the spare, strong image shown here.

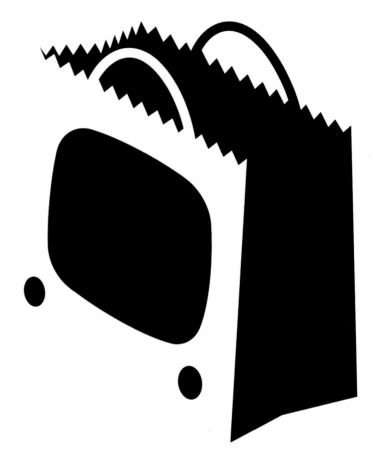

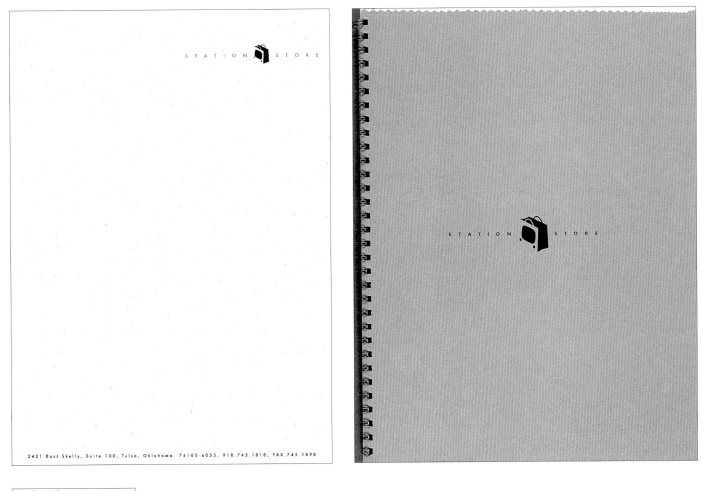

STATION STORE

2421 East Skelly, Suite 100, Tulsa, Oklahoma 74105-6053, 918.745.1818, FAX.745.1898

STATION STORE

Design Firm:
The Knape Group,
Dallas, TX
Art Director/Designer:
Les Kerr

USA NETWORKS

Orange created this logo to be used in on-air and print promotion for an original film produced and broadcast by USA Networks. During the design process, she was guided by a number of imperatives: the logo not only had to be visually powerful and reflect the film's suspenseful mood, but also had to "work" in both mediums and be reproducible in either black-and-white or color. After watching a rough cut of the film and reading the script, Orange prepared a few preliminary sketches, then began to refine the ones she liked on the computer. After presenting her initial designs to the members of USA's in-house graphics department, she focused on one logo, hand-tracing it to give it a more "distressed" look, then scanned and reworked it in Adobe Photoshop and Illustrator.

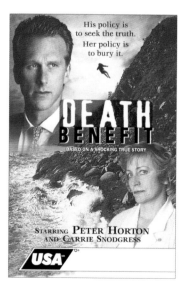

His policy is
to seek the truth.
Her policy is
to bury it.

DEATH
BENEFIT

BASED ON A SHOCKING TRUE STORY

STARRING PETER HORTON
AND CARRIE SNODGRESS

USA

Design Firm:
USA Networks,
New York, NY
Art Director:
Elisa Feinman
Designer:
Lisa Orange

From magazines and journals to digital communities, nowadays the publishing and printing industries communicate in wildly diverse media to many different audiences. A small target group makes up the readers of *Clinicians Progress Notes*, an informational medical newsletter, whereas millions around the globe have access to *Salon*, a pop culture internet magazine. Some of the logos featured in this section serve, like the logos for *Salon*, to organize information. Others are employed in marketing and corporate branding efforts. Pierce Arrow uses branding on its promotional materials, which herald the lithographer's services to fellow industry professionals; its mark, a figure aiming a bow and arrow, works both visually and literally. The logo for the *Woman's Book of Changes* appeals to female consumers with its serene face: a personal, emotional tug at the heartstrings. A dose of humor can be effective as well: a crossed knife and fork forming a Roman numeral 10 makes a visual pun, celebrating a decade in business for *Cooking Light* magazine. Created for promotion, retail sale, Web sites, and production houses, these logos share in common an ability to identify with and speak to their audience, an essential goal of communications.

Market research showed that few of Pierce Arrow's customers were familiar with the car of that name, so Art Lofgren devised a different association: a visual pun on the company's name. Lofgren had unusual freedom in designing the stationery and promotional materials depicted here: Pierce Arrow management wanted to show off the company's Pantone lithography, embossing, diecutting, and foil-stamping capabilities.

Design Firm:
SGL Design, Phoenix, AZ
Art Director:
Art Lofgren
Designer:
Art Lofgren

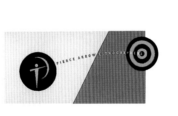

CLINICIANS PUBLISHING GROUP

Tony Urgo used Adobe Illustrator to create this logo for the masthead of a new publication targeted at doctors, nurse practioners, and other health-care providers. Conveying the information that the journal contributes to intra-professional discourse, he depicts a fountain pen—a symbol of informal, personal communication—casting the shadow of a traditional "caduceus" insignia.

Design Firm:
Sound & Fury, Inc.,
Landing, NJ
Art Director:
Sharee Carow
Designer:
Tony Urgo

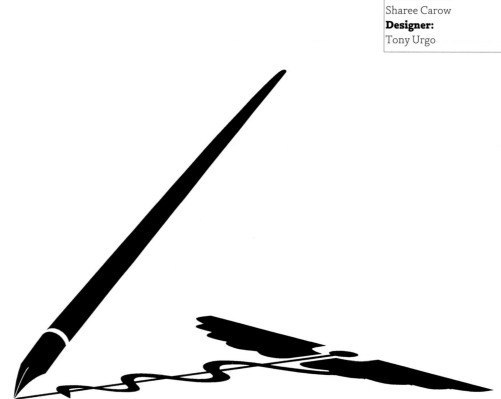

Designer/Illustrator:
Maya Metz Logue
Cooking Light magazine,
Birmingham, AL

This logo was created as part of *Cooking Light's* tenth anniversary celebration. Used in the magazine as well as on various promotional items, it features a silhouetted knife and fork crossed to form a Roman numeral 10. A second logo, printed on commemorative T-shirts, consisted of a birthday cake topped by ten asparagus-shaped candles.

COOKING LIGHT

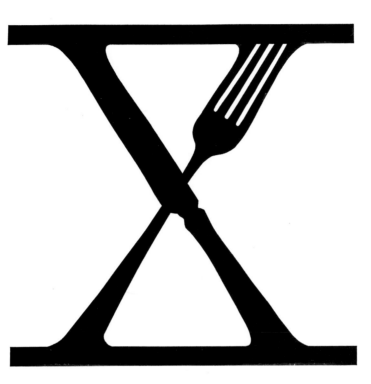

Sue Schlabach based this 4-color design on an antique print. Using Adobe Photoshop, she retinted the image for reproduction onto the company's new stationery, which had previously sported a 2-color logo.

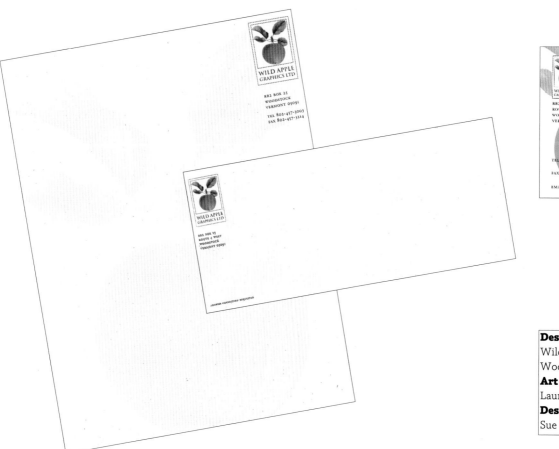

Design Firm:
Wild Apple Graphics,
Woodstock, VT
Art Director:
Laurie Chester
Designer:
Sue Schlabach

WOMAN'S BOOK OF CHANGES

Working for Tools with Heart, Inc., a firm that develops "transformative tools for self-awareness," Cooper created this logo for a new line of journals targeted to women. Cooper rejected several images that referred to the process of writing, such as a pen lying across a heart and a hand holding a pen over a book. Working in Adobe Illustrator, she developed a symbolic logo alluding to the underlying emotional aims of journal-writing—the phases of the moon stand for welcoming change, the balance of dark and light elements represents emotional harmony, while the smiling face signifies inner serenity.

Design Firm:
Kimberly Baer Design
Associates, Venice, CA
Art Director:
Kimberly Baer
Designer/Illustrator:
Barbara Cooper

Created in Adobe Illustrator, these logos provide visual breaks in this World Wide Web-based magazine's long, text-heavy table of contents; each gives a clear identity to the section it marks. The design strategy consists of a subtle color scheme and strong, simple shapes. Khargie not only gave the logos a distinctive, bold look, but also crafted them for use online without loss of image clarity.

ICONS FOR VARIOUS SECTIONS OF SALON MAGAZINE

DIGITAL CULTURE

MOVIES

BOOKS

NEWSREAL

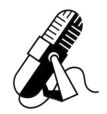

MEDIA CIRCUS

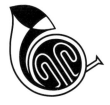

MUSIC

TELEVISION

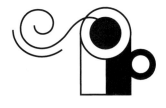

MODERN LIFE

Designer:
Mignon Khargie
Salon magazine,
San Francisco, CA

MANUFACTURERS & PRODUCTS

Products and the companies that make them—this would seem be the most tradi-
tional of the eight different types of businesses and organizations represented in
this volume. Yet, as these examples show, in meeting the challenges of an evermore
competitive marketplace, manufacturers are not afraid to hire designers who use
innovative imagery or unconventional strategies in creating logos that shape both
corporate and product identities. Many of these clients, not surprisingly, are in the
computer industry, that nexus of newness—witness Plynetic's whirling vortex,
Sumo Software's squat but elegant wrestler, and Crossroads's networked *C*.

Although many of these logos refer to concrete things, only a few depict them.
There's the Crossroads logo with its oblique allusion to networking equipment, and
the use of imagery suggestive of grain in the one for Minnesota Specialty Crops—
but most references are relatively indirect. Why is this so? The answer is simple.
Creating positive associations in the mind of the consumer, rather than specifically
depicting a product or company, is a key marketing strategy. In a competitive
marketplace where many different products can fulfill a client's needs, the image, or
"identity," of a product becomes its selling point. The fun logo for Airplane coffee,
for example, distinguishes Objex, Inc. as a hip, high-end coffee retailer. The logos
for Nike align famous basketball stars with Nike shoes, and engage consumers'
hoop dreams. A successful logo for Design-X, in which a screw and a cylinder twist
together to form an *X*, evokes the company's creative solutions. In short, the compa-
nies that attract consumers' attention are the ones that capture their imaginations.

Wholesale & Business Products

Unlike logos that promote consumer merchandise, those for wholesale and business products don't usually make personal appeals to buyers; they often refer only indirectly to the character or function of what's being sold, as in the cases of the logos for the software and high-tech companies included here. Consider Airplane Coffee's whimsical mark which presents its product to an audience of high-end retailers as "cool" and "funky," or the one created by CookSherman for Niman Schell Ranch which shows an open road rather than a steer or a side of organic beef. Even when working for businesses that don't sell directly to the public, designers are keenly aware of the need to craft logos that associate products with positive, progressive ideas.

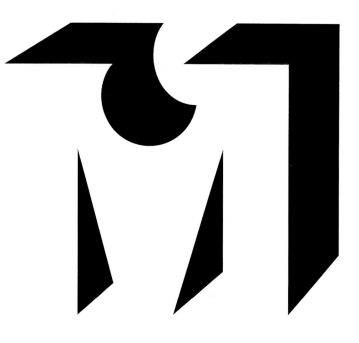

This logo evokes the client's line of business as well as a sense of its creative approach to building machine tools. Using an uppercase *M* to refer to the Messer name, Dvorak rendered a sans-serif, three-dimensional letter symbolizing solidity and professionalism. The letter's middle "dip" is cylinder-shaped to simulate the effect of a precision-cut bore hole. Dvorak worked in Adobe Illustrator and QuarkXPress.

MESSER MACHINE

Design Firm:
Balance Design,
Rockford, IL
Designer:
Scott Dvorak

Design-X is a software package containing pre-drawn engineering and architectural components that can be used within Autodesk's design programs. In crafting a logo for the product, Yelaska wanted to meet the client's request that the design incorporate an *X* and include a reference to construction. His solution shows a screw and a cylinder joined together to form an *X*. By giving the image a three-dimensional feel, he makes it more powerful and dynamic; by keeping it simple, Yelaska makes it usable not only as a logo, but also as an on-screen icon. He created the mark in Adobe Illustrator.

Design Firm:
Bruce Yelaska Design,
San Francisco, CA
Art Director:
John Seminerio
Designer/Illustrator:
Bruce Yelaska

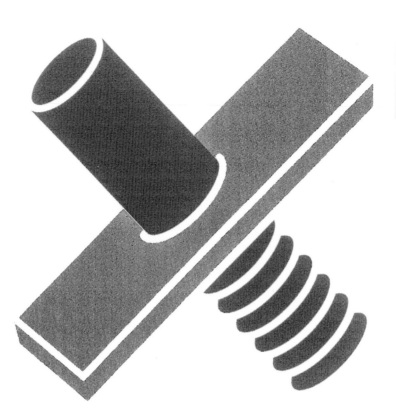

Design Firm:
Elixir Design,
San Francisco, CA
Art Director:
Jennifer Jerde
Designer:
Michael Braley

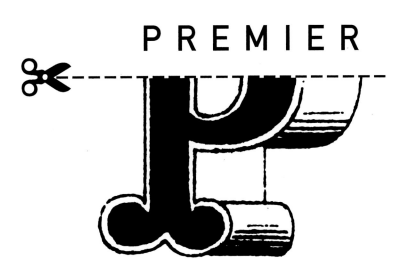

Elixir created this logo almost by accident. They had been asked by Premier, which specializes in diecutting and assembling purchase displays, to design a company brochure, whose cover was decorated with a version of the whimsical mark shown here. "We intended it to be a small 'bug' on the cover," the designers report, "but the client loved it and decided to adopt it as a logo." They created the mark using Adobe Illustrator.

PREMIER DIE-CUTTING & MOUNTING

This simple, charming logo depicts the client's software as being as tough and sure-footed as a sumo wrestler. To make her wrestler look as powerful as possible, the designer rendered him in a stark black-and-white silhouette made up of crisp geometric forms, then bordered the image with the company name in a no-nonsense sans-serif, expanded font, which suggests both modernity and professionalism.

Design Firm:
Casper Design Group,
Berkeley, CA
Art Director:
Bill Ribar
Designer:
Gin Anderson

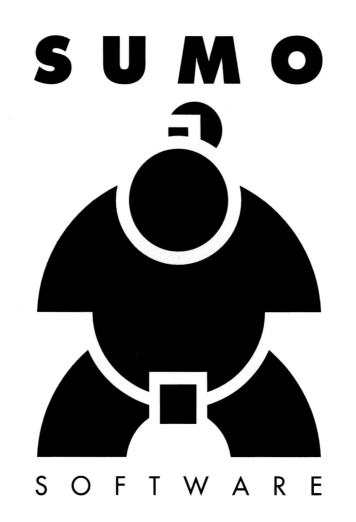

Design Firm:
Long Design,
San Francisco, CA
**Art Director/Designer/
Illustrator:**
Jennifer Long

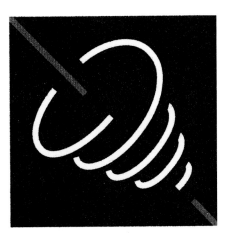

Plynetics

In devising a logo for Plynetics, which provides industrial clients with prototypes of mechanical products, Long developed an entire identity system (the company had previously used a generic logotype rendered in Garamond Bold Condensed). In so doing, she took care not to make the identity too confining, given that her client operates in a dynamic, competitive environment which might suddenly require a change in business strategy. She decided on the image of a whirling vortex—a reference to the speed with which Plynetics meets its customers' orders—cut through by the ruby red beam of a laser (used by the company in manufacturing prototypes). All the artwork was originally created in Adobe Illustrator, although the vortex was drawn using a CAD system and then "tweaked" repeatedly to give it just the right look.

PLYNETICS CORPORATION

Greg Krikorian
Direct 510 613 0578

Plynetics Corporation
627 McCormick Street
San Leandro CA 94577
510 613 8300
Fax 510 632 6682
Modem 510 632 6683
e-mail: greg@plynetics.com

Plynetics

CROSSROADS

Crossroads, which provides corporate clients with computer networking services, wanted a logo with a serious but modern and inventive look. Beginning with a sans-serif block *C*, shorthand for the company's name, Wong turned it on its side, suspended it on a grid of three interlocked axes, and placed a shadow underneath it to suggest the client's dynamism and creativity. He also rendered the shadow in an *X* shape to make it look like an actual crossroads—a symbol of networking. He worked in Adobe Photoshop, Illustrator, and Dimensions.

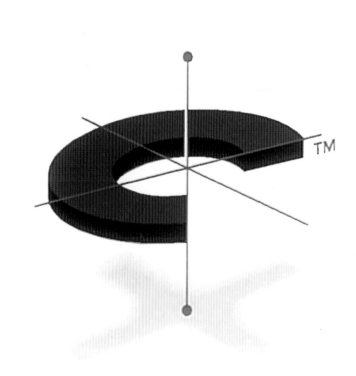

Design Firm:
Michael Patrick Partners, Palo Alto, CA
Art Director:
Dan O'Brien
Designer/Illustrator:
Robert Wong

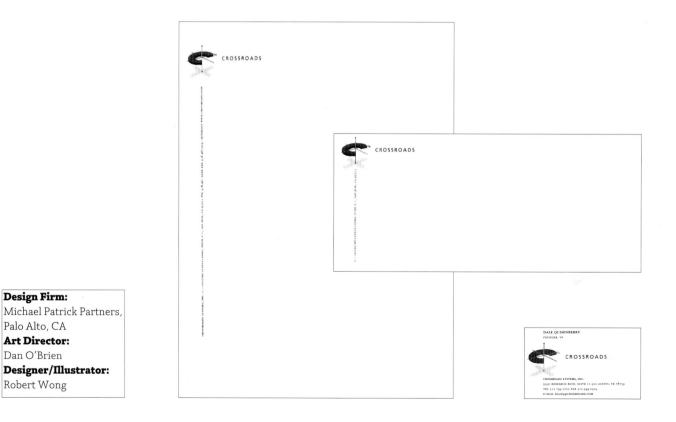

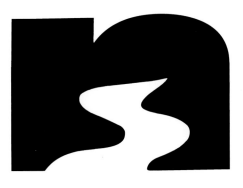

NIMAN

SCHELL

Although this California-based company's business is selling chemical- and hormone-free beef to local and New York restaurants, Cook chose not to make a cow the centerpiece of this logo, since a bovine image would be inappropriate and in questionable taste. Instead, after presenting a number of different design concepts to the client, he focused on this one, wherein a lowercase *n* resembling the ranch's main barn is split with an *s* in the shape of the road leading up to it. He created the mark using Adobe Illustrator; a combination of letterpress and offset processes was used to reproduce it on company stationery and business cards.

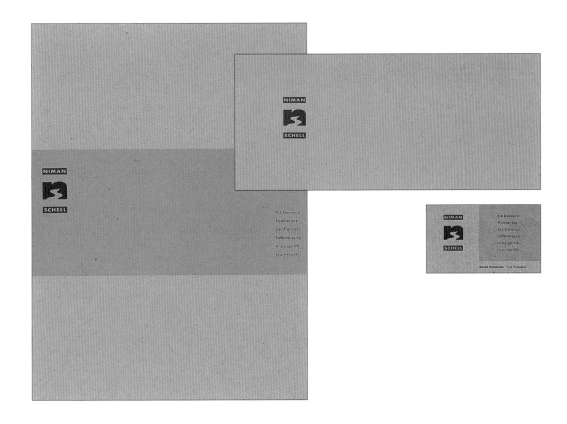

Design Firm:
CookSherman,
San Francisco, CA
Art Director/Designer:
Ken Cook

Design Firm:
Steve Trapero Design,
Silver Spring, MD
Art Director:
Deborah Howard
Designer/Illustrator:
Steve Trapero

INTERSOLV SOFTWARE

Each of these icons represents a different department in InterSolv's quarterly newsletter. In devising the set, Trapero sought an image for each that was uncomplicated, had a "high-tech" feel, and related to the subject of the particular department. Trapero notes that because of tight production deadlines, simplicity was an essential design criterion—which, it turns out, spurred him to create stark and distinctive marks that the client liked a lot. He used Adobe Illustrator to craft the set.

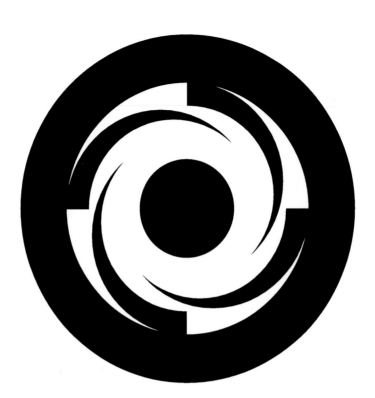

Design Firm:
Jon Flaming Design,
Dallas, TX
Art Director/Designer/
Illustrator:
Jon Flaming

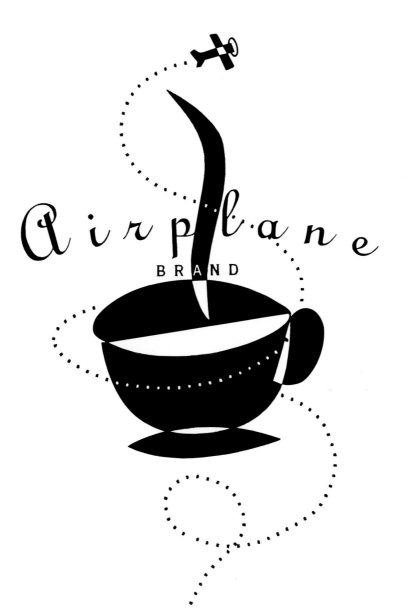

Evoking a sense of sophisti-
cation and fun with this
logo, Flaming helped the
manufacturer, Objex, Inc.,
successfully market a new
brand of private-label coffee
to high-end retailers. He
used Adobe Illustrator to
create the "kooky plane," the
type, and the steaming coffee
cup; the logo was then offset-
printed onto various product
and promotional materials.

OBJEX, INC.

Consumer Products

Buying stuff is, increasingly, the way most Americans define themselves—which means that manufacturers of consumer products are devoting more attention than ever to marketing their goods in a personalized fashion. A number of these marks and symbols show that logo design has definitely felt the effects of this trend. Witness, for example, the logos for Nike's growing line of NBA and WNBA player-endorsed basketball shoes, which don't say anything about the shoes themselves, but make it very clear which hooperstar you, the consumer, are identifying with. Consider as well the "here's a picture of what will happen to you if you take these" icons used on Lifetronix's line of vitamin supplements. Or look at the logos that suggest, if only indirectly, a certain lifestyle—those for Fishsandwych, Thump, and 8-Wave clothing lines are quintessential, as are, in a slightly different way, those emblazoned on the labels of O'Grady's various microbrews. Even the logo for PGP encryption software, which shows exactly what the product does, personalizes the issue of data security. In short, these logos work because marketing for this kind of identity is everything.

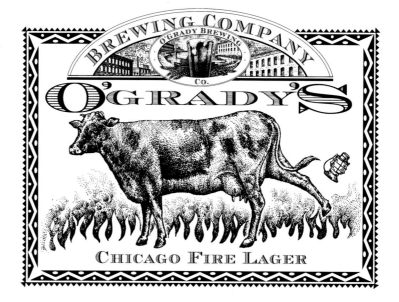

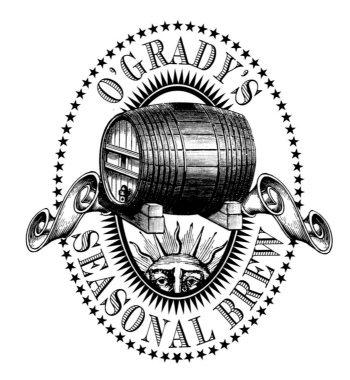

Design Firm:
The Parker Group,
Park Ridge, IL
Art Director/Designer:
Rex Parker
**Illustrator
(Chicago Fire Lager):**
Mark Larsen

In naming these new beers, Chicago's O'Grady Brewing Company sought to link each to a colorful event or character from the city's past. Parker, in crafting marks based on the names, used historical images in a fun way, calling up familiar associations and conveying a sense of the O'Grady brewpub's relaxed atmosphere. He designed the logos in Adobe Illustrator and Photoshop, as well as QuarkXPress; 2-color offset printing was used to reproduce them on bottle labels and other materials.

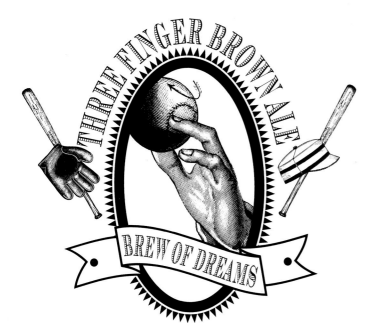

Each of these marks, created for LifeTronix's line of dietary supplements, is meant to give potential customers a "feel for what the product is about," according to the designers. In the mark for the weight-loss product Metatrim, for example, is a highly stylized representation of a person jumping in glee over a narrowing waistline. The designers used stark, semi-abstract black-and-white imagery throughout the program to give the products a more sophisticated look than that of competitive products. They began with hand-drawn thumbnail sketches, then scanned them and reworked them for reproduction using Adobe Illustrator.

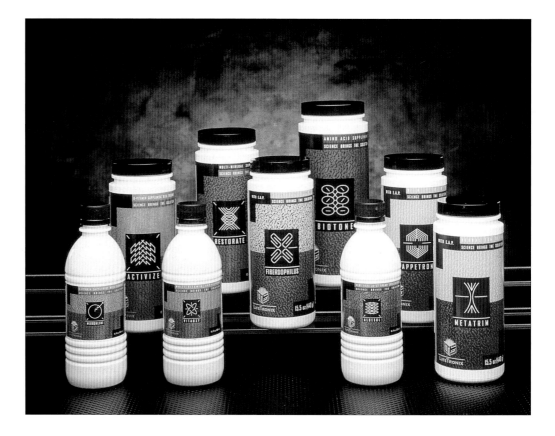

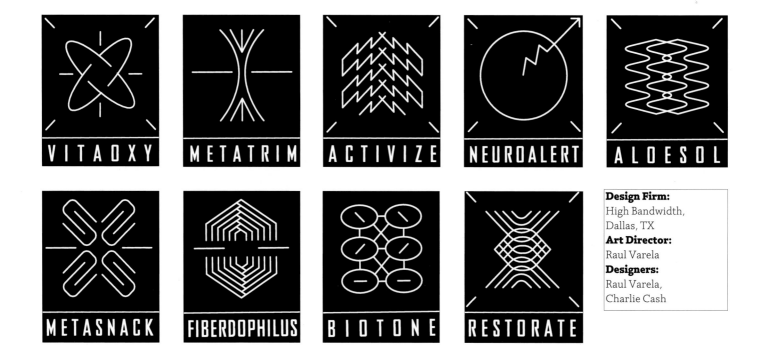

VITAOXY **METATRIM** **ACTIVIZE** **NEUROALERT** **ALOESOL**

METASNACK **FIBERDOPHILUS** **BIOTONE** **RESTORATE**

Design Firm:
High Bandwidth,
Dallas, TX
Art Director:
Raul Varela
Designers:
Raul Varela,
Charlie Cash

Design Firm:
Luba Lukova Studio,
New York, NY
Designer:
Carol Chen
Illustrator:
Luba Lukova

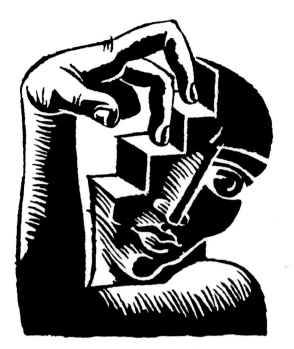

The illustration for this logo was first published in *The New York Times Book Review*. It was seen by two musicians who wanted it as the symbol for their record company, Virtual Music House. They particularly liked the way Lukova had depicted the subject's fingers climbing the stairs of his mind, almost as though they were the unusually arranged keys of a mental (or perhaps *virtual*) piano.

VIRTUAL MUSIC HOUSE

8-WAVE

With this logo for a line of beach and surfwear manufactured by the Japanese company 8-Wave, Hiraoka wanted to suggest the ocean in a straightforward, simple way. Her solution is a visual pun on the client's name, turning the number 8 into a pair of interlinked waves. By rendering the logo in 1-color, Hiraoka ensured that it would be easily and cheaply reproduced on a variety of items: company stationery, T-shirts, stickers, etc. She used Aldus FreeHand to produce the final design.

Design Firm:
Sandra Hiraoka Design,
Honolulu, HI
Art Director/Designer:
Sandra Hiraoka

THUMP

SKATETHREADS

After exploring a number of solutions playing on the onomatopoetic quality of this skateboard clothing manufacturer's name, Stucker chose to go a different route. Conveying the fun and exuberant nature of the clothing and skateboarding itself, he crafted an expressive logo that resembles urban graffiti and incorporates a set of assymetrically placed lines and curves that suggest motion and excitement. He created the logo the old-fashioned way: with pen-and-ink.

Design Firm:
Rapp Collins
Communications,
Minneapolis, MN
Designer:
John Stucker

The designers convey a sense of the cooperative nature of bicycling with a mark that can be easily reproduced on decals and castings. After rejecting the idea of using a company mascot in the logo (a bear was one idea), they settled on showing three open hands together, poised to grab a stylized handlebar. To ensure that customers would not be confused by the new logo, the designers retained the oval shape and yellow border that characterized its predecessor. The new logo was produced in Adobe Illustrator.

Design Firm:
Funk & Associates, Eugene, OR
Art Director:
David Funk
Principal Designer:
Joan Madsen
Designers:
Tim Jordan, Sandy Lui, Chris Berner, David Funk, Beverly Soasey, Kathleen Heinz

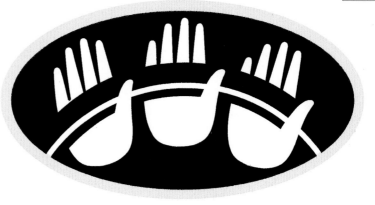

Design Firm:
Huffy Design Center,
Miamisburg, OH
Art Director:
Bill Rieger
Designer:
Gary Sanders

This logo was created for
Huffy bicycles that have
frames made from super-
strong titanium boron steel.
The centerpiece *T*, depicted
in assertive uppercase with a
thick stem, refers to the
strength of titanium, while
the swirls surrounding it
suggest speed. Aldus
FreeHand was used to
craft the logo.

Each of these graphically bold logos immediately identifies a line of shoes with the athlete for whom it was created. The Sheryl Swoopes mark consists of her initials interlocking to form a basketball, while the one for Alonzo Mourning's plimsouls incorporates both his nickname, Zo, and his uniform number, 33. Welch created both marks in Adobe Illustrator.

Design Firm:
Nike Image Design, Beaverton, OR
Designer:
Derek Welch

Design Firm:
Next Years News, Inc.,
Toledo, OH
Art Director:
Dwight Ashley
Designer/Illustrator:
Chris Hoffman

The design of a logo for a new line of casualwear for young men began with choosing a name for the product. The client wanted a recognizable and visually arresting identity—which led to the choice of "Fyshsandwych" (with *y*'s replacing *i*'s for copyright reasons). Adobe Illustrator was used to create the design, which was then screen- and offset-printed onto various materials, including the clothing itself.

CONFIDENTIAL

In February of 1953 the United States government led a campaign to seek out the world's top 3 scientists; Dr. Robert Oppenheimer, Dr. Albert Einstein, and the young *Dr. Ezekiel Fysh*. The group was told that they were building the answer to world peace. The government's real plan was to build a bomb, which upon detonation would render entire cultures (even our own) at the mercy of the United States military.

In the summer of 1954 the group separated, while *Fysh* stayed on. Later that year upon realization of the government's intent, *Fysh* took the project research and disappeared without a trace. The only evidence of the project and *Fysh's* existence to this day lie in his correspondence with us, a secret organization, code named :

FYSHSANDWYCH.

Most of the information we have on our friend *Dr. Ezekiel Xavier Fysh* is sketchy, which is probably best. We know that he was born in the late 1920s somewhere in England. By the age of ten Fysh's knowledge of chemistry, physics, and theories on genetics rocketed him to an early acceptance at Oxford. In only three years he graduated top in his class with three degrees; chemistry, physics, and fine art. By the age of twenty he was sharing his theories on uranium 235 with Oppenheimer.

To this day, though no one knows exactly where he is, *Fysh* remains one of the most highly esteemed scientists and best kept secrets in history. *Dr. Fysh* has requested that our organization relay the truth to you. Tell the untold, show the unseen, make known the dark secrets that have gone unknown for far too long.

FYSHSANDWYCH™

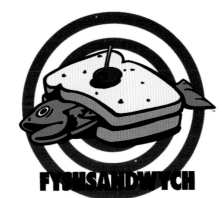

FYSHSANDWYCH

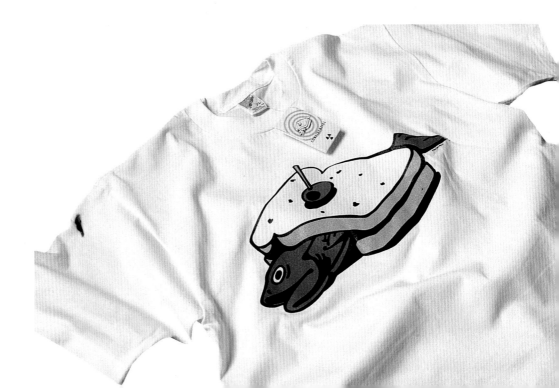

The client, a manufacturer of encryption software, wanted to allude to the service its product provides: protection of individual privacy and control over the amount and kind of that protection. In designing a logo to meet this specification, Hornall Anderson avoided symbols that had aggressive connotations or that suggested covertness or dehumanized the product. The firm's solution, achieved in Aldus FreeHand, was this compelling mark incorporating the image of a person standing behind a closed window-shade.

Design Firm:
Hornall Anderson
Design Works,
Seattle, WA
Art Director:
Jack Anderson
Designers:
Jack Anderson, Debra
Hampton, Heidi Favour,
Jana Wilson

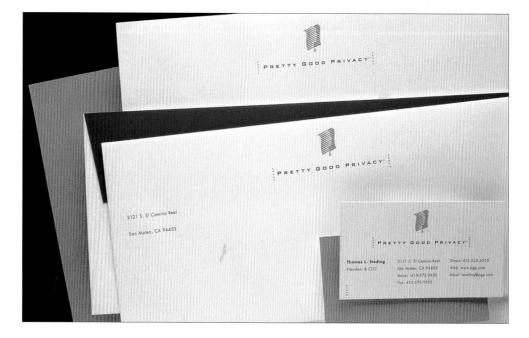

Design Firm:
Staubitz Design,
Collinsville, CT
Designers:
Robert B. Staubitz,
Jill Foxman-Staubitz

S C I E N T I F I C

Royal Consumer Business Products sought an identity as a producer of high-end, general-use calculators with scientific functions, a market the company was entering for the first time. Staubitz's solution was to give Royal's product, the Scientific, an aura of seriousness by incorporating allusions to the atom and scientific formulas, and to suggest quality and reliability by using an expanded, all-caps, serifed face for the type, and a balanced, rectangular shape for the visual. The logo was created in Macromedia FreeHand and rendered in 4-color to stand out when reproduced on the product and its packaging.

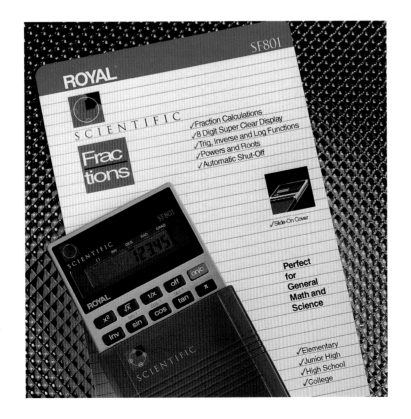

Woodward's goal was to provide a distinctly "funky" identity for this newly established business, which specializes in baking healthy cookies and producing cold-brewed organic coffee. In advance of meeting with Noble's owner to discuss the logo, Woodward considered various design concepts, including several using typical Vermont-related imagery, such as a picture of maple trees. During the client meeting, she spotted a large painting of an ocelot done by the owner's son—an image so winning that she decided to use it for the logo. After scanning her photo of the painting, she reworked it in Adobe Illustrator and exported it to QuarkXPress for final mechanical. The type was created by hand, scanned, then integrated with the image.

Design Firm:
Woodward Design,
Brattleboro, VT
Art Director/Designer:
Leslie Woodward
Illustrator:
Ian Aldridge

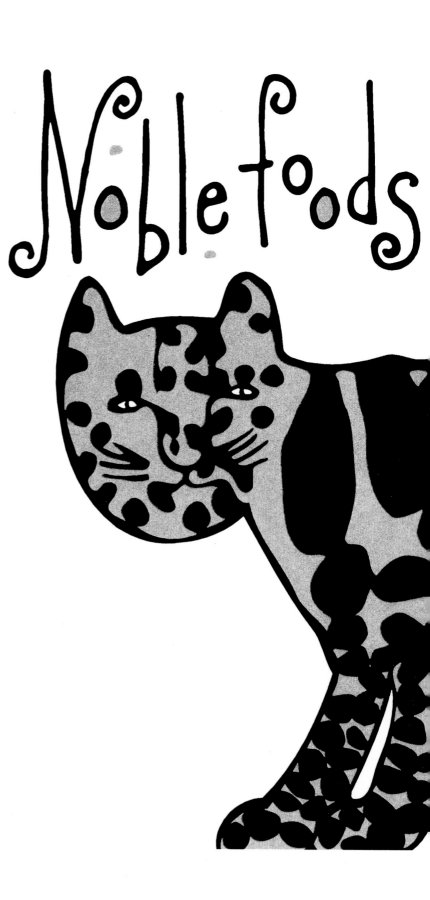

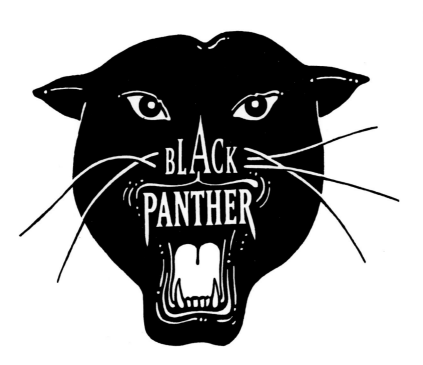

In crafting a logo for this bottled water, "Black Panther," whose target market is young, health-conscious "Generation X" types, the designers came up with an appropriately dark and fearsome image. They started with pen-and-ink drawings of a panther's face, then scanned and manipulated them using Adobe Illustrator and Photoshop, as well as QuarkXPress. Unfortunately, the client hadn't considered that the product's name calls up negative associations for many people. Once buyers pointed this out, distribution efforts were halted, and the product has yet to be brought to market.

AQUAPENN SPRING WATER CO.

Design Firm:
Sommese Design,
State College, PA
Art Directors:
Kristin Sommese,
Lanny Sommese
Designer:
Kristin Sommese
Illustrator:
Lanny Sommese

Blue Q wanted a logo for general use on its line of novelty refrigerator magnets that would convey to retail customers that its products are bold, humorous, and retro in look. The designers say that they hit on this solution, which was created in Adobe Illustrator, right away, and that the client approved it on the spot. In fact, Blue Q likes the design so much that it has had the logo reproduced not only on a product display, but also on magnets, stickers, and T-shirts.

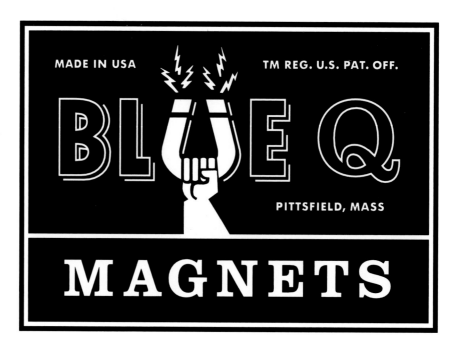

Design Firm:
Haley Johnson Design Co., Minneapolis, MN
Art Director:
Haley Johnson
Designer:
Richard Boynton
Illustrators:
Richard Boynton, Haley Johnson

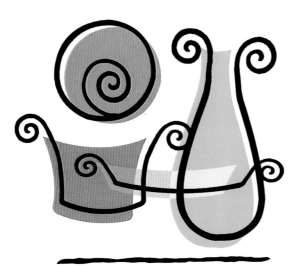

ARDITH ©
PLIMACK
DESIGNS

For this start-up business, which creates cups and other dishware for Starbucks and other high-end specialty food service companies, the designers crafted a mark that captures the flavor of the client's products. The logo, which adorns Ardith Plimack's stationery and business cards, was created using Adobe Illustrator and Photoshop.

ARDITH ©
PLIMACK
DESIGNS

136 Almenar Dr Greenbrae CA 94904 415 464 0817 FAX 461 7460

136 Almenar Dr

ARDITH © Greenbrae
PLIMACK CA 94904
DESIGNS
 415 925 1731

 FAX 461 7460

136 Almenar Dr Greenbrae CA 94904 415 464 0817 FAX 461 7460

Design Firm:
CookSherman,
San Francisco, CA
Art Director:
Ken Cook
Designers:
Ken Cook, Inka Mulia
Illustrator:
Inka Mulia

In devising this logo, Planet Design sought to create a myth—an imaginary place where mutual respect reigns between humans and nature. The other goal was for a mark that looked as if it were the signature for an old-fashioned master craftsman. By arranging rough-hewn versions of the letters *M* and *W* along a curved line, the designers produced an image reminiscent of just such a signature, and suggests an imaginary mountain forestscape to boot. After creating the logo by hand, they "weathered" it by photocopying, then scanned it for print production.

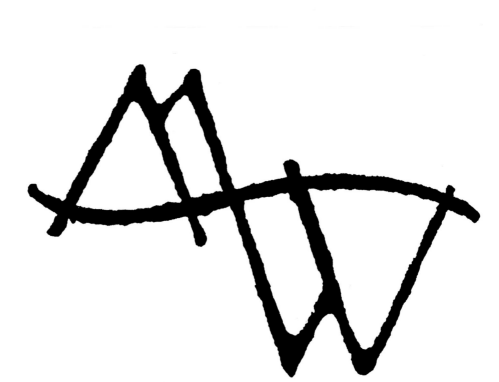

Design Firm:
Planet Design Company,
Madison, WI
Art Directors:
Kevin Wade,
Dana Lytle
Designer:
Martha Graettinger

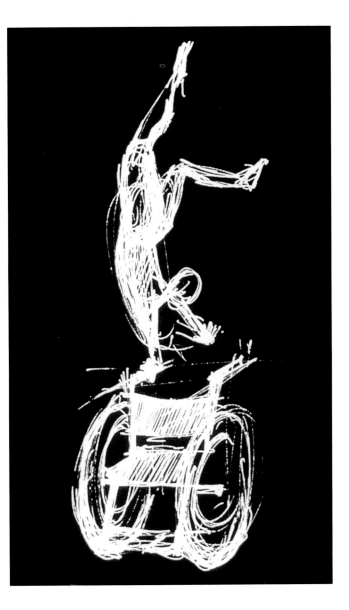

The Center for Assistive Technology specializes in finding and procuring such devices as wheelchairs and hearing and sight aids, often at no charge to its clients. In this logo, the designers sought to emphasize the "assistive" side of the Center's work, while playing down the "technology" side—a goal they achieved by showing a person using his or her wheelchair to perform a joyous handstand. The logo was originally created as a thumbnail sketch on tracing paper, then blown up, scanned, and reworked using Adobe Photoshop.

CENTER FOR ASSISTIVE TECHNOLOGY

Design Firm:
Muller + Company,
Kansas City, MO
Art Director:
Susan Wilson
Designer:
Jeff Miller

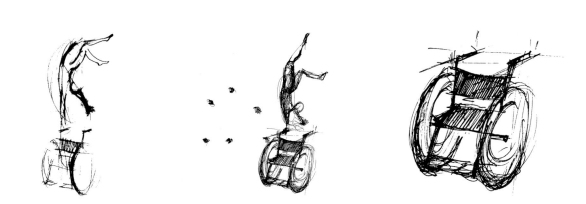

Cominiti viewed this job as a challenge: "I had to create a strong visual and verbal identity for this generic sleeping aid, making it memorable while demonstrating its benefits." His apt solution—a logo in which the *e* is shown "at rest"—ensures that potential customers will not only remember the product's name, but associate it with its intended function. He enhanced this effect by adding a night-sky background in a calming combination of blue and black. Cominiti created the mark in Adobe Illustrator.

Design Firm:
Peter Cominiti Design,
New York, NY
Art Director/Designer/
Illustrator:
Peter Cominiti

NONPROFIT
ORGANIZATIONS &
INSTITUTIONS

Although designers aren't concerned with "selling" when they create a logo for a nonprofit organization, they do employ design techniques similar to those used to enhance for-profit businesses. They not only demonstrate the client's specialty, but also convey a sense of quality and expertise. A good example is the International Association of Women Chefs and Restaurateurs logo, which is made of crisply rendered symbols of cooking, dining, and business. And when a non-profit is operating in a competitive environment, a strong, distinctive identity is as important as it would be to a for-profit business—see the logos for Amazon University and the Connecticut Culinary Institute.

In the case of charities and other public-service organizations, it's common to see motifs, illustration, and type styles that impart a sense of caring, hope, and personal attention. The logo for the Children's Health Fund, for example, contains imagery of just this sort—much as logos for personal services firms often do. And in marks created for recreational, hobby, and educational nonprofits—such as those for the Wana Zoo, the South Alabama Birding Association, the Yosemite Camera Walk, and the U.S. Space and Rocket Center—imparting a sense of pure fun or discovery is clearly paramount. Whether profit or non-, it would seem that many of the same design strategies are at work.

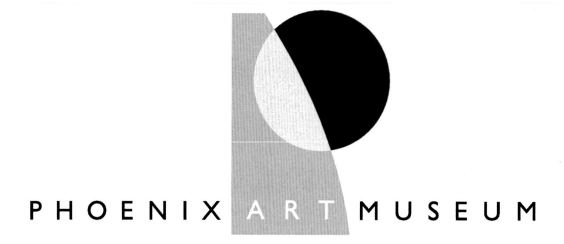

PHOENIX ART MUSEUM

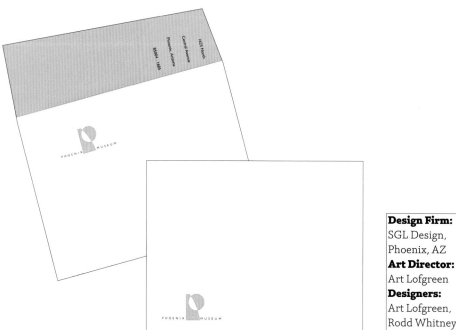

Design Firm:
SGL Design,
Phoenix, AZ
Art Director:
Art Lofgreen
Designers:
Art Lofgreen,
Rodd Whitney

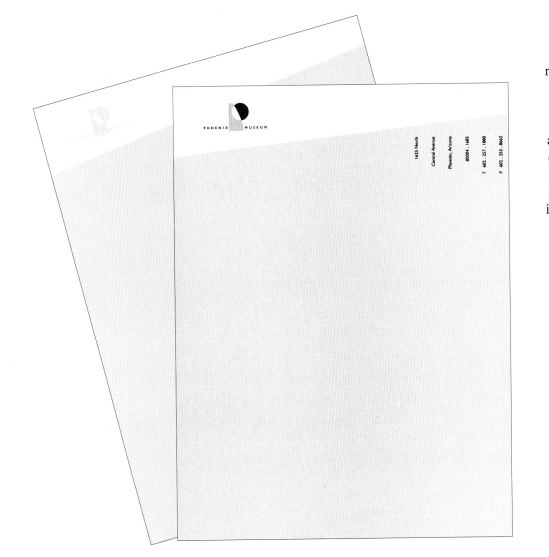

This logo incorporates a stylized representation of the Phoenix Art Museum's recently completed signature building. SGL notes that presenting a design of any sort to a group of art aficionados can be a difficult experience, but the museum trustees were unanimous in approving this logo. Created in Adobe Illustrator, the logo adorns the Phoenix Art Museum's stationery.

This "full identity system" replaces an earlier logo, which used a similar simple, elegant typeface but did not feature playful animal images. Supon's assignment was "to appeal to a broad audience of both children and adults—to be playful, but not to focus too narrowly on kids," which led the designers to offset the colorful drawings with a more sedate background and typeface. The logos were drawn up in QuarkXPress and Adobe Illustrator; standard offset was used for producing printed materials featuring them. For signage and other non-printed products, screen printing was employed.

Design Firm:
Supon Design Group, Washington, DC
Art Director:
Supon Phornirunlit
Identity Designer/ Illustrator:
Sharisse Steber
Product Designer:
Brent Almond

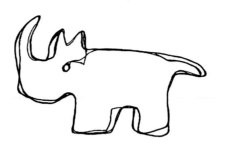

W A N A Z O O

W A N A Z O O

W A N A Z O O

W A N A Z O O

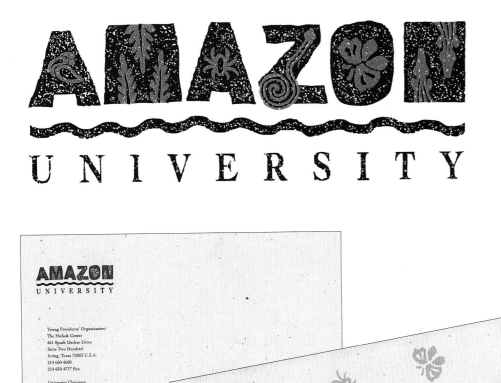

The "Amazon University" is
an educational seminar for
corporate CEO's and presi-
dents sponsored by the
Texas-based Young
Presidents Organization and
held in the Amazon jungle.
Working in Adobe
Illustrator and QuarkXPress,
Savage created a bold logo
that conveys a sense of
exotica and adventure and
can be offset-printed onto
University stationery.

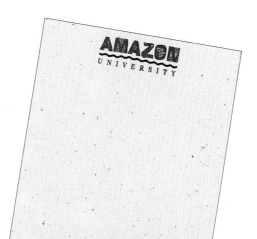

Design Firm:
Savage Design Group,
Houston, TX
**Art Director/Designer/
Illustrator:**
Dahlia Savage

THE PARK PRESERVERS

The Park Preservers, a non-profit group dedicated to preserving open land near State College, Pennsylvania, for use as parks, wanted their logo to convey the notion that human society and the natural world are inextricably linked. The Sommeses modified a drawing of a bird they had found in a book—they transformed the tail into outstretched human hands—and hand-lettered the organization's name to complete the logo.

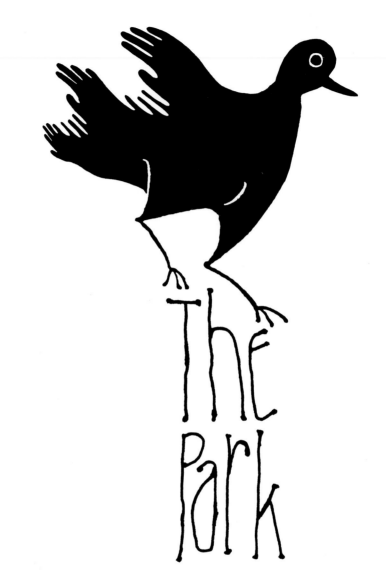

Design Firm:
Sommese Design,
State College, PA
Art Directors:
Lanny Sommese,
Kristin Sommese
Designer:
Kristin Sommese
Illustrator:
Lanny Sommese

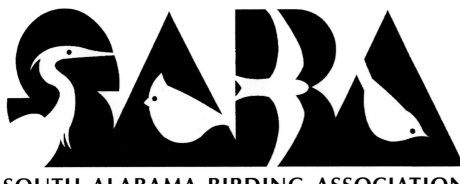

SOUTH ALABAMA BIRDING ASSOCIATION

This new organization sponsors a series of bird-watching field trips in the South Alabama area. Markle developed a design that reproduces equally well on T-shirts, hats, name badges, and a newsletter masthead. She drew four species of birds—the great blue heron, northern cardinal, purple martin, and brown-headed nuthatch (left to right)—that are either indigenous to the region or stop there during spring migration, and shaped them into the acronym SABA.

Design Firm:
Studio A,
Greenville, AL
Art Director/Designer:
Annabel Markle

CONNECTICUT CULINARY INSTITUTE

Using Adobe Illustrator, Mota created a logo that fulfilled two needs. It reproduces well in 1-color, and also lets the audience—which includes both potential Institute students and the general public—know what business CCI is in. In addition, the logo suggests a sense of sophistication and quality in line with the Institute's long-standing commitment to fine cuisine.

Design Firm:
Wondriska Russo
Associates,
Farmington, CT
Art Director:
William Wondriska
Designer:
Maria F. Mota

WOMEN CHEFS & RESTAURATEURS

Schowalter used Adobe Illustrator and QuarkXPress to assemble this simple, straightforward logo. Each of the three symbols represents a different aspect of the food industry—the fork refers to the preparation and maintenance of dining facilities, the whisk stands for cooking, and the paper clip suggests restauranting's business side. Working on a tight budget, the client used 1- and 2-color offset printing on the various informational publications that are distributed to its members and fellow food-industry professionals.

WOMEN CHEFS & RESTAURATEURS

Design Firm:
Toni Schowalter Design,
New York, NY
Art Director/Designer:
Toni Schowalter

By using familiar symbols in a new way, the designers of this logo present the New York State Democratic Party as first and foremost a patriotic institution. After rejecting other designs—including a silhouette of New York State morphing into a star—they settled on the iconic image and color scheme of the American flag. Using Adobe Photoshop and QuarkXPress, they merged text and image, topping it all with a star for emphasis.

THE NEW YORK STATE DEMOCRATIC COMMITTEE
THE NEW YORK STATE DEMOCRATIC COMMITTEE
THE NEW YORK STATE DEMOCRATIC COMMITTEE
THE NEW YORK STATE DEMOCRATIC COMMITTEE
THE NEW YORK STATE DEMOCRATIC COMMITTEE
THE NEW YORK STATE DEMOCRATIC COMMITTEE
THE NEW YORK STATE DEMOCRATIC COMMITTEE

THE NEW YORK STATE
DEMOCRATIC COMMITTEE

THE NEW YORK STATE
96
DEMOCRATIC COMMITTEE

THE NEW YORK STATE DEMOCRATIC COMMITTEE

Art Director:
Andrew Kner
Designers:
Andrew Kner,
Diego Vainesman

N E W Y O R K L A N D M A R K S

P R E S E R V A T I O N F O U N D A T I O N

This design, which replaces a logo consisting only of a line of type set in Times New Roman, adorns various educational and fundraising materials distributed by the Foundation. The buildings are actual New York townhouses—a familiar part of the city's historic environment. Seipher manipulated the images in Adobe Photoshop, then created the type and laid it out using QuarkXPress.

NEW YORK LANDMARKS PRESERVATION

Design Firm:
Christopher Johnson & Associates,
New York, NY
Art Director:
Christopher Johnson
Designer:
Reed Seipher

For this organization, which unites mothers of AIDS patients in the fight against the disease, the Sloan Group wanted to avoid sappiness. They also didn't want the symbol to represent small children exclusively. Their design incorporates stylized stick figures whose joined hands not only suggest cooperation and compassion, but also form an interlocked *M* and *V*. The figures were initially hand-drawn, then scanned in and refined using QuarkXPress and Adobe Illustrator.

MOTHERS'
VOICES
United to end AIDS

Design Firm:
The Sloan Group,
New York, NY
Creative Director:
Cliff Sloan
Designer:
Lana Le

This logo appeals to a wide audience ranging from the children served by the Children's Health Fund (CHF) to corporate sponsors, employees, and volunteers. It replaces CHF's existing logotype, in which an apple was used to dot the *i* in the word "Children's"—which led many to believe that this nationwide non-profit works only in New York City. The new logo does not incorporate any region-specific imagery and can be a stand-alone symbol. Logos including toys were rejected by CHF, which is very cautious about using imagery that could be regarded as childish—rather than "child-like"—or trite. The sun was chosen for its positive associations; the figure of the child with upraised arms suggests health and happiness. The symbol was originally rendered by hand, then scanned into Adobe Photoshop and reproportioned in Adobe Illustrator —without removing the rough edges that give it a "non-institutional" feel. It is used on materials of all sorts, including silk-screened T-shirts and offset-printed stationery.

Design Firm:
Shanosky & Associates, Baltimore, MD
Art Director/Designer:
Adam Shanosky

Working for the Ansel Adams Gallery, Osborne captured the feeling of nature photography in this logo, thus appealing to amateur picture-takers interested in taking part in the gallery's Yosemite Camera Walk program. He sketched this logo by hand, then scanned it and touched it up using Aldus Freehand.

The Camera Walk.

Yosemite National Park

Design Firm:
Michael Osborne Design,
San Francisco, CA
Art Director/Designer:
Michael Osborne

Pathology Education, Inc.

This firm, which creates and conducts continuing-education seminars for pathologists, wanted immediate visual recognition among potential students—it considered its previous logo, the initials "PEI" backed with a "swoosh" motif, to be too bland. Making a bolder statement, one that was not "cute or flip," Barton tops a microscope with a mortarboard, establishing a clear association between the firm's educational and medical missions. She created the logo using Adobe Photoshop and QuarkXPress.

Design Firm:
Jane Barton Studio,
Tucson, AZ
Art Director/Designer/
Illustrator:
Jane Barton

This logo was developed for two types of documents: requests for corporate sponsorship and materials distributed at an exhibit on the history of Hollywood science fiction films. Using Adobe Illustrator, the designers created a distinct comic-book feel, recapturing the flavor of early '50s Buck Rogers-style movies.

Design Firm:
Deep Design,
Atlanta, GA
Designer:
Mark Steingruber
Illustrator:
Chris Spollen

Peteet eschewed making a figure *25* the centerpiece of this anniversary logo. To convey a sense of the Center's mission to be "a caretaker of the world's oceans and seas," he created and arranged three recognizable symbols of the sea—the Roman god Neptune (identifiable by his crown and trident), holding a shell and flanked by a silhouetted seahorse. The design was crafted in Adobe Illustrator.

CENTER FOR MARINE CONSERVATION

Design Firm:
Sibley/Peteet Design,
Austin, TX
Art Director/Designer:
Rex Peteet

Designing a new logo for Kelmscott Farm, which preserves rare animal breeds, was part of a marketing effort recently launched by Farm management. The owner, a devotee of William Morris, wanted not only to convey a sense of the farm's mission, but also to reflect an Arts and Crafts ethos. Chambers included a "folksy" depiction of a Cotswold sheep—the farm's feature animal—and used a color palette and typeface reminiscent of Morris's works. Van Dusen, moreover, gave a woodcut look to his drawing of the sheep and the farm. Beyond this, however, stylization was at a minimum—the imperative to depict the rare sheep accurately led to the rejection of portraying only its head, and a concern to show the whole farm meant that the frame was made square, rather than oval or lozenge-shaped. Aldus Freehand and QuarkXPress were used to put it all together. Letterpress printing was used for the gray outlines; offset for the rest of the logo. Farm business cards are made from handmade paper incorporating wool sheared from its own Cotswolds.

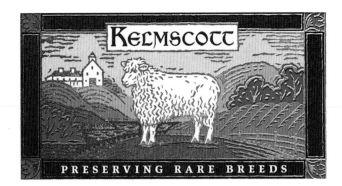

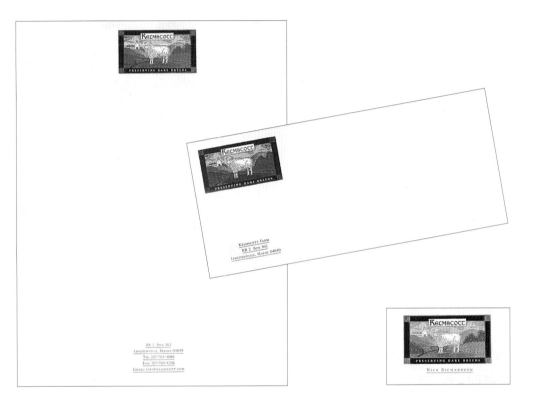

Kelmscott blanket, naturally inspired.

Design Firm:
Ariel Creative (formerly Searls Design), Rockport, ME
Creative Director:
Randy Searls
Art Director/Designer:
Kathleen Chambers
Illustrator:
Chris Van Dusen

WESTMINSTER

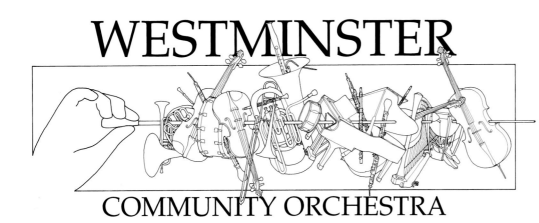

COMMUNITY ORCHESTRA

Lissé developed a multi-purpose logo that clearly identifies the group as an orchestra, makes its name recognizable, and distinguishes it from its competitors. WordPerfect was used to set the titles, while all the images were hand-drawn with pen-and-ink, modeled on a hand holding a baton, actual instruments, and catalog illustrations. A photo of the master logo was then supplied to the orchestra's sponsor, the Westminster Conservatory, which reproduced it on T-shirts, brochures, and various other items.

Design Firm:
lissé [design],
Princeton, NJ
Designer:
Alexander Lissé

The City of San Francisco recently created this non-profit organization to serve as a central coordinator for all city-wide cleanup services. In creating its first logo, Thomas was concerned to help the organization win public acceptance by steering a path midway between the literal ("cleaning up" imagery might be too limiting) and the abstract (which might make it seem too distant and institutional). The response to his hand-lettered *N* design, which has a decidedly friendly feel, has been overwhelmingly positive—Thomas notes proudly that one city resident says he "felt like Superman" when wearing his Neighbors for Neighborhoods T-shirt.

Design Firm:
Brad Thomas
Graphic Design,
San Francisco, CA
Designer:
Brad Thomas

Design Firm:
Croxson Design,
Bellaire, TX
Art Director:
Stephen Croxson
Designers:
Michael Ratcliff,
Stephen Croxson

Urban Harvest

The target audience for this logo was current and potential volunteers and contributors to Urban Harvest, a network of gardeners and orchard-keepers who use vacant urban lots to grow food for charitable distribution and teach city dwellers to use land more wisely. In replacing its old logo—which consisted merely of the words "Urban Harvest" set in Algerian—the organization's leaders wanted an identifiable corporate signature in which its name would be more legible. The logo incorporates two images—a corn husk and a skyscraper—that, in combination, are both memorable and suggestive of Urban Harvest's unique mission. In order to ensure that reproduction costs would be minimal, Ratcliff and Croxson designed this logo to print effectively both in 2- and 1-color publications. Working from a set of initial pencil drawings, they refined the logo in Adobe Illustrator; the stationery package and brochure were created in QuarkXPress.

This logo, created in Adobe Illustrator, was designed to be offset printed on materials distributed by the Humane Society's to publicize its annual Pet Walk-a-Thon. Since both dogs and cats were included, Stiles chose a humorous image—a dog, restrained by its owner, chasing a cat. Depicting the three figures walking in a circle emphasizes the duration of the event.

Design Firm:
GSD&M Advertising,
Austin, TX
Designer:
Brett Stiles

RESTAURANTS & RETAIL

The nature of restaurant and retail businesses means that their logos must accomplish a task that is doubly difficult. Clients in these fields seek not only to market the food and other products their businesses sell, but also to bring customers to a specific location to buy them—many clients want logos that both create a product identity and convey a distinct and appealing sense of place. As the examples shown here demonstrate, designers approach this challenge in different ways.

One popular technique is to give a logo a look reminiscent of the place it represents. When crafting a mark for a dining room or retail space, some designers use the same color scheme or style of imagery, as in the case of Amazing Glaze pottery-painting studio. In certain instances, such as those of the Starland Cafe and Havana Moon Cigar and Coffee Shop, the logo serves as the basis for an interior design strategy that's applied later on.

Others, meanwhile, impart a more general sense of mood or atmosphere. The tricolor detailing in Starbucks's Frappucino logo, for example, transports the customer to Italy, while its "Classic Siren" evokes the magic of a mythical place that one presumes can only be reached after drinking a great deal of strong coffee.

Which approach is more effective? Obviously, this question can be answered only in the context of a specific design problem, but take a look at these logos to get some initial reactions.

Restaurants

Creating a sense of place is important to restaurants and cafés—after all, food is more easily and cheaply prepared and consumed at home. Additionally, a well-crafted identity not only entices customers to "give this place a try," but is an integral component of an overall dining experience. Increasingly, as these examples show, the task of creating a logo for use on menus and business cards is undertaken in conjunction with devising a look for the restaurant interior. And sometimes—as in the case of Global Dining's several establishments—this integrative approach can inspire logo designs suggestive not only of place, but of a rich and rewarding dining experience. Bon appetit!

Design Firm:
JAK Design,
New York, NY
Art Director/Designer:
Jill Korostoff

This logo, which Korostoff created for a "nuevo Latino" Manhattan restaurant, features an image of a sea urchin—*erizo* in Spanish—culled from *Hecks Pictorial Archive of Nature and Science.* Other versions of the logo feature the same background and lettering along with images of other sea creatures, suggesting the varied nature of Erizo Latino's offerings, as well as providing a slightly different look for each of the items on which a logo is used—menus, invitation cards, etc. Korostoff used Adobe Photoshop in crafting her design, and QuarkXPress to do the layout.

ERIZO LATINO
422 West Broadway
SoHo, New York
212.941.5811

ERIZO LATINO RESTAURANT

After considering several other concepts, the designers, inspired by a piece of primitivist sculpture, used an image of an awakening stick figure. Playing on the café's punny name, they depicted the figure emerging from a coffee cup with messy hair—a sure sign of its having just woken up. The design was created in Adobe Illustrator.

Design Firm:
Strong Productions, Inc.,
Cedar Rapids, IA
Art Director:
Todd Schatzberg
Designers:
Todd Schatzberg,
Matt Doty, Julie Kim

Classic Siren

Giving personality to the siren figure in the familiar Starbucks logo was Lemley's goal in creating this symbol, which is used on company promotional materials. Because the siren conveys a sense of caffeine's powerful allure, Lemley sought to make her even more seductive in this silhouetted design. The symbol is based on a hand-drawing which he scanned and then touched up in Adobe Photoshop before using Aldus Free-Hand's pen tool to convert it into a vector-based image.

Frappuccino

In creating this logo, the designers sought an identity for this new beverage (jointly marketed by Starbucks and Pepsi-Cola) that would say "Starbucks," not only to patrons of the company's cafés, but also to shoppers in deli's and grocery stores, where the product is also sold. Additionally, they sought to convey the idea that Frappucino is not only a new brand, but creates its own new beverage category. After creating a custom wordmark and treating it with red and green to give it an Italian aura—a subtle reference to the high-quality coffee the beverage contains—they added a swirl pattern that reflects the drink's tone by changing from a deep, rich hue at the bottom to a lighter, whipped look at the top. This pattern also makes subtle reference to designs created by Hornall Anderson for use on much of Starbucks's early coffee packaging. Aldus FreeHand was used to put it all together.

Classic Siren
Design Firm:
David Lemley Design,
Seattle, WA
Designer/Illustrator:
David Lemley

Frappuccino
Design Firm:
Hornall Anderson
Design Works,
Seattle, WA
Art Director:
Jack Anderson
Designers:
Jack Anderson,
Julie Lock, Jana Nishi,
Julie Keenan, Mary Chin
Hutchison, Julia Pine

Boelts Brothers based this logo on a very simple notion: that good coffee and comfortable chairs are the two things café-goers love most. The design began with a pencil drawing of an easy chair—a reference to the eclectic, homey furniture found at the Epic—which was then scanned in and modified with Adobe Photoshop and Aldus FreeHand. Perhaps it was the unique nature of their fee that motivated the designers to come up with such an elegantly basic design solution—in exchange for creating this logo, they'll receive free coffee for life!

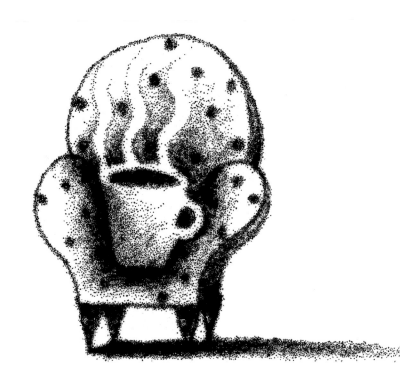

Design Firm:
Boelts Brothers
Associates,
Tucson, AZ
Art Director:
Jackson Boelts
Designer:
Eric Boelts
Illustrators:
Eric Boelts, Jack Green

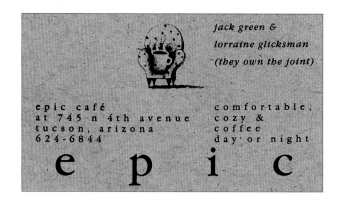

*jack green &
lorraine glicksman
(they own the joint)*

epic café comfortable,
at 745 n 4th avenue cozy &
tucson, arizona coffee
624-6844 day or night

e p i c

The owners of this restaurant—one of whom had been a member of the Starland Vocal Band—specified only that its new logo had to include its name. For his part, Severson attempted a design solution that would not rely on the image of a star. He almost succeeded—the stars in the final logo, which outline a knife and spoon "constellation," aren't immediately visible. This design, which Severson created in Adobe Illustrator, was the first and only one presented to his client, who loved it at first sight. The signature constellation motif proved very portable—Severson later used it as the basis for the restaurant's menus, and included it in dining-room murals as well.

STARLAND CAFE

Design Firm:
Signal Communications,
Silver Spring, MD
Art Director/Designer:
Scott Severson

GLOBAL DINING, INC.

These four logos were crafted by Vrontikis Design as part of a total identity program for Global Dining, Inc. Each logo is meant to convey a sense of the elegance, attention to quality, and international atmosphere that characterize Global Dining's 22 restaurants. In developing them, the designers faced the challenge of having to work from only a "conceptual" description provided by the client months in advance of the actual restaurant openings. In some cases, a few fabric swatches provided by the interior designers were all Vrontikis Design had to work from.

Global Dining

For the first logo, designed for the parent company, Vrontikis used the figure of a globe as the central image. The globe was taken from a drawing provided by the client. On the corporate business card, the designers carefully arranged the Japanese- and English-language contact information to emphasize the company's cross-cultural nature; Vrontikis used both QuarkXPress and Adobe Photoshop in preparing the final design.

Tableaux Lounge

The use of rich, reddish browns in the Tableaux Lounge logo serves to suggest its warm, luxurious atmosphere. The image of a row of cigars is taken from a stock photograph, with the "smoke" effect added later in Photoshop.

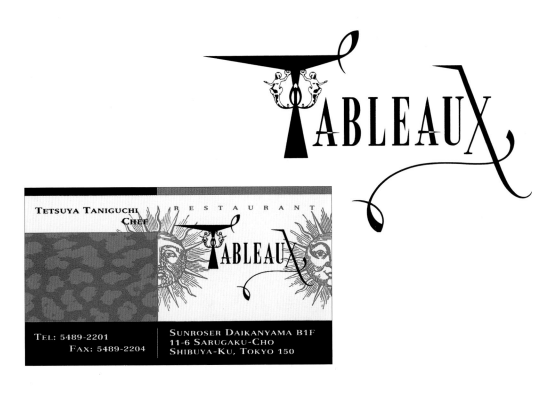

Tableaux Restaurant
The third logo designed for Tableaux Restaurant, incorporates the same signature logotype found in the Tableaux Lounge identity. Additional motifs are adopted from fabric patterns from the restaurant's interior, as well as others from various symbol reference books. The final design was created on Adobe Illustrator and QuarkXPress, with offset lithography used to print the logo onto the various items in the restaurant's stationery.
Café La Bohème
The fourth logo for Café La Bohème, resulted from the client's request that the designers come up with something suggestive of the restaurant's "eclectic, romantic, progressive" character. The mélange of imagery used throughout the identity includes a fleur-de-lis, the design pattern on a swatch of fabric from the restaurant's interior, and a reproduction of a lush vegiform pattern taken from an encyclopedia of engravings. Adobe Photoshop and Illustrator, as well as QuarkXPress, were used to put it all together.

Global Dining, Inc.
Design Firm:
Vrontikis Design Office,
Los Angeles, CA
Art Director/Designer:
Petrula Vrontikis

Tableaux Lounge
Design Firm:
Vrontikis Design Office
Art Director:
Petrula Vrontikis
Designers:
Kim Sage, Lorna Stoval

Tableaux Restaurant
Design Firm:
Vrontikis Design Office
Art Director:
Petrula Vrontikis
Designer:
Kim Sage

Café La Bohème
Design Firm:
Vrontikis Design Office,
Los Angeles, CA
Art Director:
Petrula Vrontikis
Designer:
Kim Sage
Logo Designer:
Peggy Woo

The owner of the Fuel House, a Wilmington, Delaware, coffee shop catering to a breakfast and lunch crowd, wanted a logo that would make passersby curious enough to go inside. Halbig used Adobe Streamline and Aldus FreeHand to devise this design, which centers on the image of a gas pump, a reference to the morning or afternoon "pick-me-up" potential customers might be looking for. In an effort to give the logo a fun, friendly look, Halbig anthropomorphized the pump, making its main volume curved like a human body and forming its hose and handle to make them look like two human arms.

Design Firm:
Ten Adams Corporation, Evansville, IN
Art Director/Designer/ Illustrator:
Darren Halbig

the Dog House
Waikiki

good food - good price

Ken Takahashi
(good boy)

the Dog House
Waikiki

Sit: King's Village
131 Kaiulani Avenue
Speak: (808) 923-7744
Fetch: (808) 574-2052

Design Firm:
VOICE Design,
Honolulu, HI
Art Director/Designer:
Clifford Cheng

The owner of this Waikiki snack shop wanted to replace an existing logo, whose centerpiece was a cartoon of a dog house, with something fun, memorable, and marketable. Cheng rejected several ideas, including a photo of an actual dog house (which would not have informed potential customers that they can eat at the Dog House) and one of a dog dish (eliminated because it might have left the impression that the café's offerings taste like dog food). He decided on the photo of a dog biscuit emblazoned with a distressed-Courier logotype, whose positive associations, says Cheng, suggest that diners will "get a reward or a treat for eating at the Dog House." After using a flat-bed scanner to scan an actual dog biscuit, he touched up the image, then used Aldus FreeHand to create the logotype. On the company business cards, Cheng separated the type and image in order to allow the word "snack" to come through on the biscuit.

D'AMICO & PARTNERS

This logo, created as part of a total position strategy for a new Minneapolis restaurant, has a look that is at once retro and contemporary—a reflection of Campiello's "comfortable yet trendy" atmosphere. Seeking to duplicate the look of 1920s and '30s poster art, which provided the inspiration, the designers hand-drew the lettering, then shaded and textured it in Adobe Photoshop. Offset lithography was then employed to print the finished logo onto stationery and menus; other uses have included magazine and billboard advertisements.

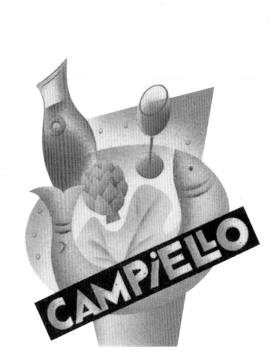

Design Firm:
Little & Company,
Minneapolis, MN
Art Director:
Jim Jackson
Designer:
Kathy Soranno

Appetizers

SPICY FRIED CALAMARI with Lemon Parsley Aioli 7.50
GRILLED TOMATO BREAD 6.50
GRILLED TOMATO BREAD with Anchovies 7.50
CAMPIELLO HOUSE SALAD 5.00
CAESAR SALAD small/ 4.50 large/ 7.50
ARUGULA with Aged Ricotta and Citrus 7.50
MIXED GREEN SALAD 3.95
SOUP OF THE DAY

Wood Oven Pizza

MARGHERITA, Tomato, Basil and Fresh Mozzarella 7.95
SMOKED MOZZARELLA, Eggplant and Crushed Tomatoes 8.50
ROASTED OYSTER MUSHROOMS, Spinach and Fontina 8.50
HAM, MUSHROOM, GRUYERE and Parsley 8.95
CHICKEN, SICILIAN ONIONS and Pecorino Romano Cheese 9.50

Campiello Rotisserie & Grill

GRILLED SALMON
with Baked Borlotti Beans and
Gremolada 13.95

SPIT ROASTED CHICKEN
with Roasted Mushrooms and
Spinach Risotto 11.95

SPIT ROASTED PORK LOIN
with Potato Puree and
Artichokes 12.95

Entrées

PENNE with Chicken, Artichoke, Garlic and Basil 8.95
TAGLIATELLE with Campiello Ragu 8.95
SPAGHETTI with Smoked Tomatoes, Spinach and Mushrooms 7.95
CHICKEN AND ROASTED PEAR SALAD with Gorgonzola and Candied Walnuts 8.50
CAMPIELLO SANDWICH with Cured Meats, Peperoncini, Tomatoes and Onions, with Garlic Potato Chips 7.95
CHICKEN SALTIMBOCCA SANDWICH with Tomato, Onion, Gruyere and Garlic Potato Chips 8.50

Desserts

WARM CHOCOLATE TRUFFLE CAKE 4.95
ROASTED APPLE TART with Balsamic Caramel Sauce 4.95
MEYER LEMON CROSTATA 4.50
TIRAMISU' 4.95
ITALIAN COOKIE PLATTER 4.50

Beverages

ESPRESSO 1.50
CAPPUCCINO 2.50
CAFFE' LATTE 2.50
SAN PELLEGRINO SMALL 2.50
SAN PELLEGRINO LARGE 4.50
CHIPPEWA SPRINGS 1.75
COCA-COLA IN BOTTLE 1.75

Design Firm:
Felix Sockwell Creative,
San Francisco, CA
Art Director/Designer:
Felix Sockwell

FIREHOUSE HOT 'N' SPICY

A powerfully suggestive image intended to call up immediate associations—heat and food together mean "hot food"—gives this logo its strong impact. Sockwell chose this idea over another that would have featured the name "Firehouse" in what he calls "diner-esque type." He saw the fork-and-fire image as being at once more communicative and (paradoxically) "cool." Achieving a craft-y, cartoon-y look with a cut-paper figure, he then scanned and refined it using Adobe Illustrator. Because one of Firehouse's three owners disliked the logo, it has never been used permanently; Sockwell hopes that the fact that it has won several design awards will change his mind.

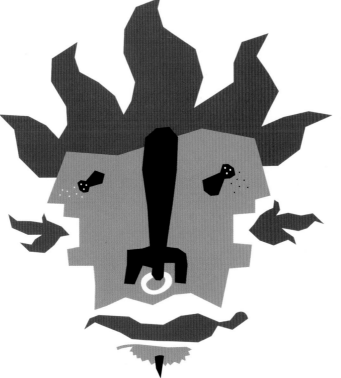

Rough napkin sketches and a lot of animated conversation fueled the design process from which this fun, straight-forward logo emerged. Working on a low budget, Ludwig touched up Fanning's Adobe Illustrator image with QuarkXPress to ready it for use on a wide variety of materials, including signage and stickers. It was so well-received by the client that it served as the inspiration for the shop's interior décor.

Design Firm:
Ludwig Design, Inc.,
Kansas City, MO
Art Director/Designer:
Kelly Ludwig
Illustrator:
Jim Fanning

Café Concepts wanted to highlight the "bicoastal" nature of the cuisine offered by the Redeye Grill, a brief that resulted in the designers' use of an airplane—a symbol of transcontinental travel—as the logo's centerpiece. A clip art image was scanned and then refined using Adobe Illustrator and Photoshop. The finished logo, which has been well-received by client and customers alike, adorns a wide array of items used at the restaurant, including signage, menus, matchbooks, and stationery.

Design Firm:
The Sloan Group,
New York, NY
Creative Director:
Cliff Sloan
Designer:
Janette Eusebio

In creating this logo, Hirschmann cleverly combined two symbols with particular appeal to young urban professionals—the buffalo is the mascot of the University of Colorado's famous football team, and a frosty mug of beer is the mascot of microbrew lovers everywhere. Joining them together was easy, given that the buffalo face seen from the front is similar in shape to a glass seen from the side. The logo, created in Adobe Illustrator (Hirschmann used the "roughen" filter to give it a hand-crafted look), has been used on a variety of items, including caps and prospectuses distributed to potential investors.

Design Firm:
Communication Arts,
Boulder, CO
Art Director:
Richard Foy
Designer/Illustrator:
Karl Hirschmann

Design Firm:
EAT Inc.,
Kansas City, MO
Art Director:
Patrice Eilts-Jobe
Designer/Illustrator:
Tony O'Bryan

WHEELIN' & MEALIN'

EAT Inc. created this logo for "Wheelin' & Mealin'," a summer event in which participants travel by trolley between four Kansas City dining establishments run by PB&J Restaurants, enjoying a four-course meal along the way. The image on the sign, in which a "curves ahead" arrow squiggles downward to become a fork, is a light-hearted combination of symbols of food and travel. Images were created from scratch; QuarkXPress, Aldus Photoshop, and Aldus FreeHand were used to put it all together. This project spawned a similar event, the "Cattle Crawl," which is run by PB&J Restaurants on behalf of the Kansas Beef Council.

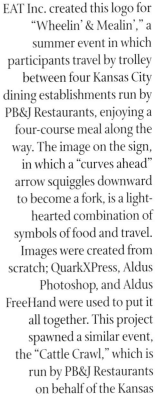

PB&J RESTAURANTS

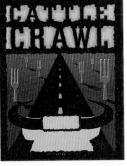

SPEND AN EVENING GRAZING ON EXCEPTIONAL COWTOWN CUISINE AND LEAVE THE DRIVING TO US!

ON SUNDAY EVENING, AUGUST 18, 1996, WE'LL HEAD 'EM UP AT GRAND ST. CAFE FOR AN APPETIZING STARTER, THEN JUMP ON A TROLLEY AND MOVE 'EM OUT TO COYOTE GRILL, YIAYIA'S AND PAULO & BILL. AT THE END OF THE EVENING, WE'LL ROUND 'EM UP AND MOSEY ON BACK TO GRAND ST. CAFE. IT'S POSITIVELY THE MOST PROGRESSIVE WAY TO DINE!

BEEF UP YOUR SUNDAY NIGHT! FOR RESERVATIONS CALL 561-8525. $65 PER PERSON INCLUDES 4-COURSE MEAL AND WINES.

EACH GUEST WILL RECEIVE A CATTLE CRAWL POSTER AND FREE RECIPE PACKAGE CONTAINING ALL THE BEEF COURSES SERVED.

SPONSORED BY THE KANSAS BEEF COUNCIL AND PB&J RESTAURANTS, WHEELIN' & MEALIN'.

Retail

As can be seen by several of the examples in this section, many retailers are not as concerned as restaurant owners with "placing" their businesses. In the case of The Laughing Cat, for example, designer Keith Greenstein focuses on creating a sense of warmth and play, while the logos for Thomassen Used Cars and Planet Comics have a traditional product orientation. But as the Puerto Rico Factory Shops and Amazing Glaze logos show, putting place first can be an effective technique for retailers. In the former instance, the use of distinctive "local" imagery helps give an identity to that most anonymous of places, a mall, while in the latter, designer Mimi Eanes matches her logo's look to that of her client's store interior, which gives customers visual encouragement to recall their most recent visit. In these two examples, the experience of place plays an integral role in shaping the consumer's image of the retailer.

Design Firm:
Kiku Obata & Company,
St. Louis, MO
Art Director/Designer:
Rich Nelson

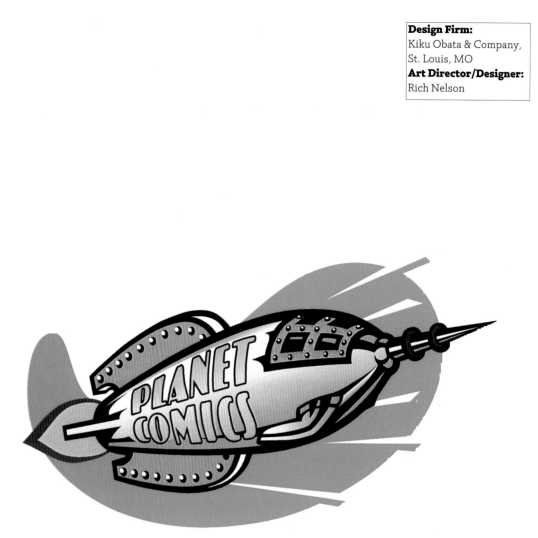

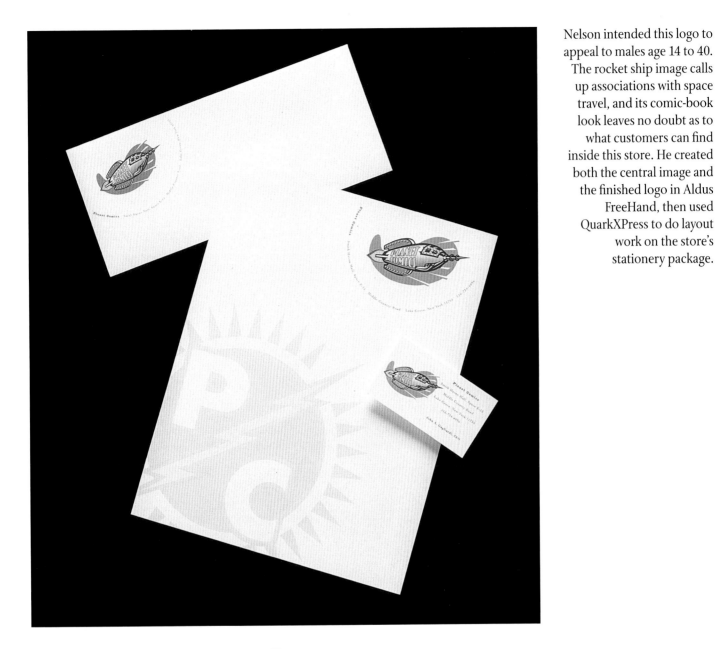

Nelson intended this logo to appeal to males age 14 to 40. The rocket ship image calls up associations with space travel, and its comic-book look leaves no doubt as to what customers can find inside this store. He created both the central image and the finished logo in Aldus FreeHand, then used QuarkXPress to do layout work on the store's stationery package.

Amazing Glaze customers choose from a selection of various ceramic objects—including mugs, plates, and bowls—then hand-paint them in the store. The store's owners wanted an eyecatching, colorful logo that would convey a sense of the fun of pottery-painting to passers-by and lure them in to give it a try. Eanes's solution was to put a picture of a palette behind one of a brush painting a piece of pottery, creating a lively image that lets potential customers know that Amazing Glaze is a "hands-on" place. The logo's bright colors—two of which were matched to those on the store's interior walls—and rough-hewn type indicate that the atmosphere is fun and informal. Eanes hand-drew everything first, then scanned it, and outlined the images and type using Adobe Streamline.

Design Firm:
Studio 13,
Charlottesville, VA
Designer/Illustrator:
Mimi Eanes

Design Firm:
Joseph Rattan Design,
Plano, TX
Art Director:
Joseph Rattan
Designers/Illustrators:
Brandon Murphy,
Diana McKnight

Prime Retail, a developer, wanted a logo for one of its numerous outlet malls that would call up associations with the mall's surroundings. The designers chose the toucan for the central image. Using an encyclopedia depiction as their starting point, they created the bird in Adobe Illustrator. The designer then developed two additional images, flowers and a frog, and applied them to stamps as part of an overall graphic system.

PUERTO RICO FACTORY SHOPS

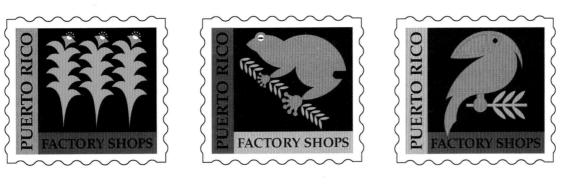

This logo for a new children's bookstore incorporates an image of a cat that Greenstein hand-drew from life—it's the bookstore owner's own feline, in fact—which, he swears, smiles broadly all the time. He notes that the figure of the laughing cat also calls up associations with the large number of children's books that feature endearingly mischievous animals.

THE LAUGHING CAT
CHILDREN'S BOOKS AND SUCH

THE LAUGHING CAT
CHILDREN'S BOOKS AND SUCH

Design Firm:
Tongman Creative,
Decatur, GA
**Art Director/Designer/
Illustrator:**
Keith Greenstein

The manufacturers of the Hamberdog, a fast-food product sold at convenience stores, wanted to convey that their product was fun to eat. Witt used Adobe Illustrator to craft this design, which is based on a hot dog–shaped, stylized canine image that is a visual pun on the product name.

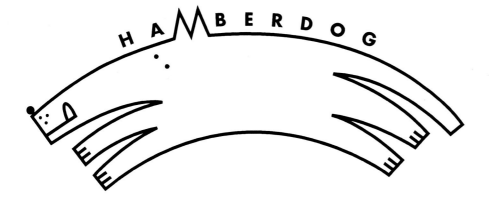

Designer:
Melissa Witt, Irving, TX

Because this car dealership sells later-model, better-quality vehicles than others in its line of business, the designers were careful to give its logo a look that would appeal to an upscale audience. They devised a design that said "automobile," but had a much more contemporary feel than other dealers' logos—thanks to the blocky, sans-serif typeface and the image of a hubcap similar to those found on higher-priced cars. The logo was created in Adobe Illustrator; the layout for the stationery was done in QuarkXPress.

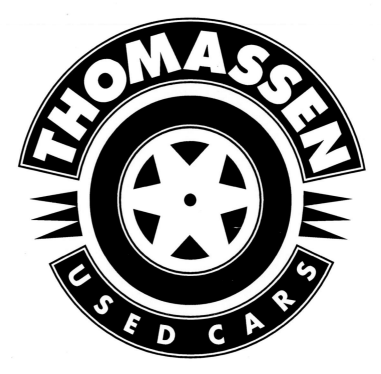

Design Firm:
Jon Walker
Graphic Design,
Shenandoah Jct., WV
Art Director/Designer:
Jon Walker
Illustrator:
Mark Fertig

SECOND CHANCE FINANCING AVAILABLE

FORD
MERCURY
CHRYSLER
PLYMOUTH

DODGE TRUCKS
DODGE
JEEP
EAGLE

MICHAEL STOCK
100 S. WEST STREET • CHARLES TOWN, WV 25414
OFFICE 304.725.0867 • HOME 304.263.1817

Even though financial profit was not the goal for the organizers of most of the events featured in this section, the logos fulfill a promotional function similar to those done for profit-seeking ventures. Conveying a sense of what an event is about, who'll be taking part in it, and what the advantages are, is, after all, not too different from promoting the benefits of a consumer product. In publicizing a one-time or infrequently staged event, designers seek to emphasize both the specialness of the event and why one would want to participate in it. Often, this simply means having a little fun—the Bay to Breakers logo, for example, doesn't just show a man running, but gives him a clown nose—while the mark created for the Jeep and Eagle Dealers' Association consists of a kooky rebus rendering of the name "Palm Springs," and that for the Pensacola, Florida, Surf Music Fest features a similarly kooky rendering of, well, a kook! In other instances, joyous, even celebratory imagery illustrates an event's unique character, as in the logo for the Cazenovia Festival of Growth, and the graceful icons of athletes in motion created for the 1996 Summer Olympics. Whatever the approach, though, conveying a sense of an event's distinct identity is clearly the key to luring participants and spectators—just as it is for designers of logos for businesses seeking to attract new customers while keeping the ones they have.

Calvary Chapel, a non-denominational Pensacola church with an extensive following among local youth, and Surf Service, an organization that provides ocean and general surfing information, join each year to sponsor a free surf and music festival featuring well-known surfers and bands. The '96 festival was the first to have a logo, which organizers wanted to be easily reproducible on T-shirts, caps, and stickers, and project a high-energy, hip look. An earlier design concept based on a realistic depiction of a surfer riding a wave was rejected as hackneyed; Westmark created this logo using Adobe Illustrator, Adobe Photoshop, and QuarkXPress.

Design Firm:
John Westmark
Illustration &
Graphic Design,
Pensacola, FL
Art Director/Designer:
John Westmark

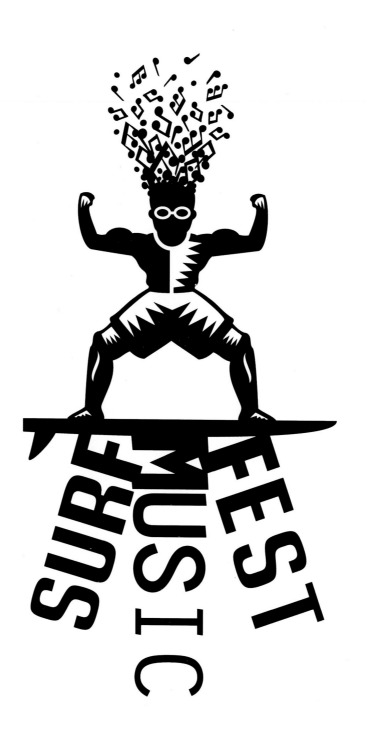

Design Firm:
Sibley/Peteet Design,
Austin, TX
Art Director:
Rex C. Peteet
Designer:
Derek Welch

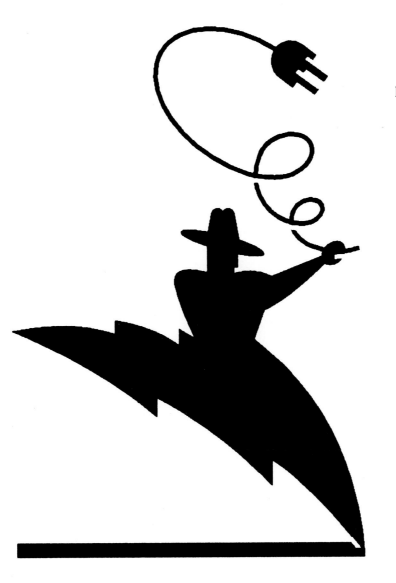

ENERSHOP

The designer based this logo on the image of a cowboy on horseback—evocative of the "rodeo" theme for this company's annual picnic. He then turned the cowboy's lariat into a power cord, a symbol for electricity provision, one of Enershop's three main lines of business (the others are telephone and general communications services). Adobe Illustrator was used to create the logo.

RAMSEY COUNTY

In designing a logo for use on educational materials distributed by the client, Hall took an image from a common school drawing exercise in which a child traces his or her own hand and then adds detailing to turn it into a "bird." He chose this image, he explains, because it was at once graphically simple and suggestive of various aspects of the complex issue of intra-family and -community violence. The raised hand suggests both violence and initiative, is a common sign for "stop," and can take the shape of a dove, a symbol of peace. Hall produced the final art using Aldus FreeHand.

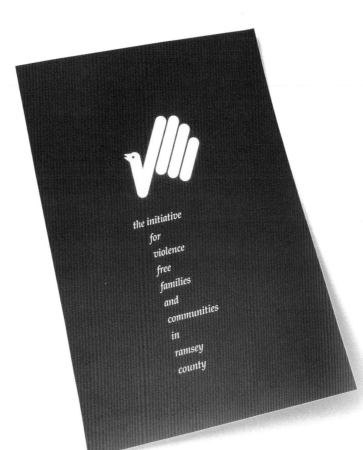

the initiative
for
violence
free
families
and
communities
in
ramsey
county

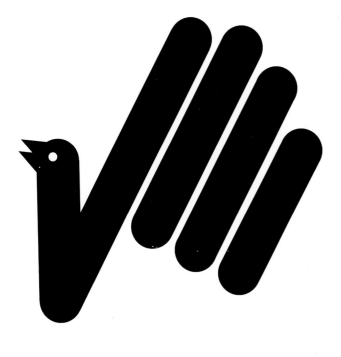

Design Firm:
Hall Kelley, Inc.,
Marine on St. Croix, MN
Designer:
Michael Hall

This 2-color logo was silkscreened onto uniforms worn by this Minneapolis-area high school's Science Olympiad team. The designer wanted the logo to be science-related as well as capture the fun and excitement of the event itself. Working on a pro-bono basis, he originally drew the image by hand.

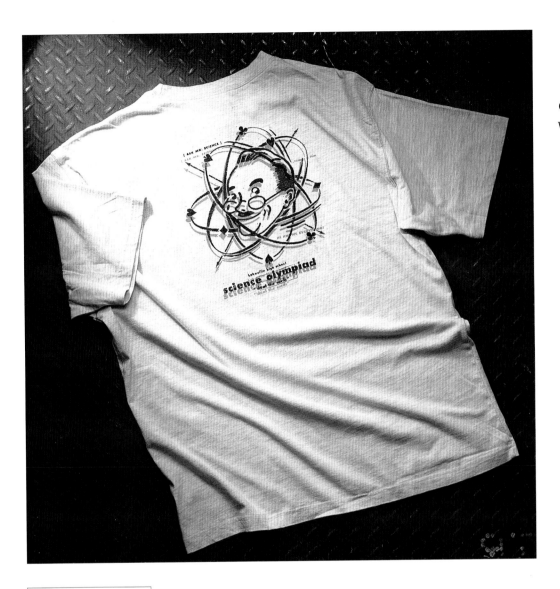

Design Firm:
Carmichael Lynch,
Minneapolis, MN
Art Director/Designer/
Illustrator:
Peter Winecke

These pictograms represent only one part of Grear's contribution to the 1996 Summer Olympics—his firm was also responsible for the design of the gold, silver, and bronze medals given to event winners, as well as for the hand-held torch used in the opening ceremonies. In each case, the designers sought to combine motifs that conveyed a sense of the Olympic heritage with others suggestive of Atlanta's traditional hospitality. Figures inspired by those on ancient Greek amphora (water jugs) were the basis for an updating of the pictograms that mark modern Olympic event sites. They also project a sense of southern grace. The designers initially made rough pencil sketches of manikins, then solicited comments from former Olympians employed by the Atlanta Games Committee (ACOG) before revising them for scanning and reworking in Adobe Illustrator. Each pictogram was then constructed using a "kit of parts"—head, foot, thigh, forearm, and so forth—broken off from one of original Illustrator drawings. In this way, although the various "parts" were often modified—foreshortened or extended—to fit the particular pose in which the athlete

was being shown, a common look among all pictograms was assured. Once they were completed, laser prints were sent to ACOG for its approval; final revisions were made based on its members' suggestions. Completed artwork was delivered both on diskette and in high-resolution Linotronic printouts, ready for distribution and reproduction both by the Committee itself and the thousands of Games licensees.

Design Firm:
Malcolm Grear
Designers, Inc.,
Providence, RI

Because the Jeep and Eagle Dealers' Association holds its Annual Presidents' Meeting in a different place each year, it sought a logo that would be in some way site-specific. In creating a design that alluded to the meeting location—Palm Springs—Ajlouny eschewed clichéd desert and sun imagery in favor of a verbal-visual pun. Without information from the client about how exactly it would be used, she created a simple black-and-white design in Adobe Illustrator; it was later reproduced on meeting materials using various printing processes.

Design Firm:
The Hot Shop
Design Group,
Southfield, MI
Creative Director:
Frank Brugos
**Art Director/Designer/
Illustrator:**
Gloria Ajlouny

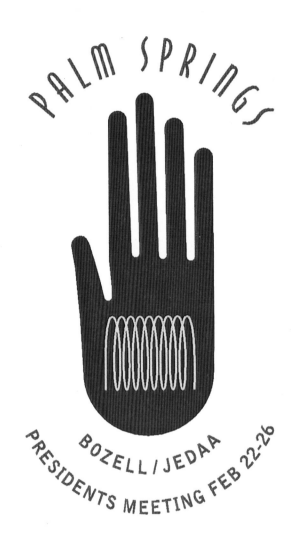

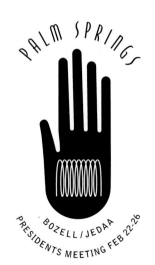

Design Firm:
Jowaisas Design,
Cazenovia, NY
**Art Director/Designer/
Illustrator:**
Elizabeth Jowaisas

Festival of Growth ❀ Celebrate as the Cazenovia Public Library turns a new page in its life during grand opening ceremonies Sunday, January 7, from 2 until 4 p.m.! ❀ Then rediscover why your library has always been the community's center for fun, learning and growth with a week of special events beginning January 8th. ❀

Jowaisas developed this logo to commemorate the grand opening of the newly renovated and expanded Cazenovia Public Library. Library management wanted something with an upbeat feel, that would appeal to children and adults alike, and that would not incorporate any winter-holiday imagery, even though the ceremony took place in December. Jowaisas chose a lively combination of vegiform and book imagery, which was well-received by the client and library patrons. She created the logo using Aldus FreeHand.

For this logo, the designers wanted to evoke the San Francisco Film Festival's international character, while focusing on the art of filmmaking itself. The image of a film director/camera-person in motion requires no text to explain what is being promoted, thus rendering it comprehensible to non-English speakers. The logo was created in Adobe Illustrator, then reproduced using various processes on various materials, including programs, banners, and T-shirts.

SAN FRANCISCO
INTERNATIONAL
FILM FESTIVAL

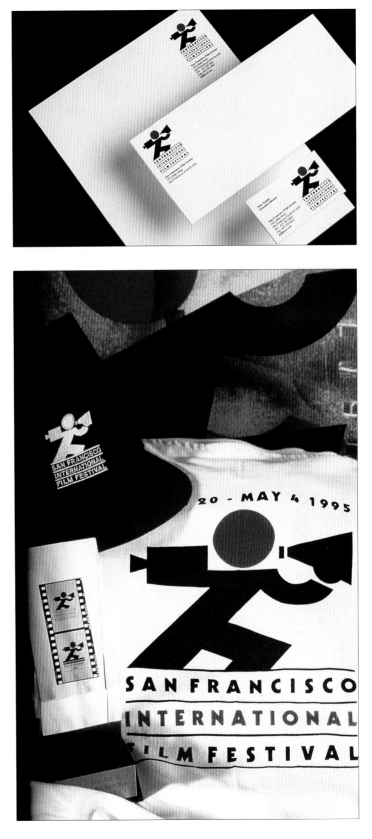

Design Firm:
Primo Angeli, Inc.,
San Francisco, CA
Art Directors:
Primo Angeli,
Carlo Pagoda
Designers:
Marcelo de Freitas,
Primo Angeli

Schumaker's "running Mercury with a clown nose and banana peel" logo perfectly captures the zany spirit of the *San Francisco Examiner's* annual "Bay to Breakers" 7 ½-mile charity roadrace, in which a few professional runners are joined by thousands of other participants dressed in silly and often highly inventive costumes—and by a few who, like Mercury, aren't dressed at all. Schumaker drew the logo by hand, using pen and ink, conveying a sense of the race's casual feel. It was silk-screened onto T-shirts and other paraphernalia, and Pantone-printed onto stationery used by the race's organizers.

Designer:
Ward Schumaker,
San Francisco, CA

This logo, an imaginary "advertising and design factory," was crafted for the Advertising Federation of Wichita's 1995 awards show. Wippich and Hogan began with the Federation's original "Willy Wonka" theme, creating an "Addy Factory," where great ideas are made. The "rough, weathered, retro" look of the various promotional materials was inspired by photos Wippich and Hogan took while walking through a steel plant after hours. They scanned the photos into Adobe Photoshop, then gave them a rough-textured look before importing them into Aldus FreeHand, where they crafted the final design. Lettering was then done by hand.

Design Firm:
dotZero
Wichita, KS
**Art Directors/
Designers:**
Jon Wippich,
Karen Hogan
Illustrator:
Jon Wippich

Pender used the theme of "Broadway style" to give a high-fashion feel to his logo, which was designed for an annual fashion show sponsored by this Buffalo-area all-girls Catholic high school. "Its simplicity is its beauty," Pender says, pointing out that he rejected more complicated concepts such as skyscrapers depicted as people and a head wearing a hat in the shape of the Manhattan skyline. The logo was created in Aldus FreeHand, and was executed in black-and-white for easy photocopying onto tickets and programs.

broadway style

Design Firm:
Crowley Webb &
Associates,
Buffalo, NY
**Art Director/Designer/
Illustrator:**
Dion Pender

SERVICES

Service companies are not only ubiquitous, but play an absolutely integral role in almost every area of everyone's daily work and personal life. Recently there has been explosive growth in the computer, financial, and consulting industries, but the service sector also includes businesses as diverse as writers, house painters, construction companies, and dentists.

It's difficult to categorize the logos in this section in a few sentences—with so many companies doing so many different things, designers obviously can't rely on using the same strategies repeatedly. However, designers almost always seek to convey a sense of the quality of the services their client provides, and also the notion that this is done with a great deal of care and consideration. Logos for business services involve, on the whole, a more traditional design approach than those for consumer services—see the playful but classic mark for Craig Singleton Hollomon Architects. Logos for consumer services display a more personal touch. The friendly, neighborhood feel of Dr. Rand Bennett's crooked picket fence is as welcoming and accessible as the handymen icons of Complete Connection's Home Team. Creating a coherent, marketable identity is an ever-present concern in the service industries as elsewhere, particularly in the case of small firms working in very competitive areas, and others looking to make just the right impression.

Business Services

These logos are more restrained, both visually and conceptually, than those for personal-service firms, as is perhaps in keeping with the more buttoned-up nature of the business-services market. Conveying a sense of warmth and informality is clearly a secondary goal for these designers—witness the example of EDAW's Earth Day logo, where the "friendly" feel of the central lower-case e *is balanced by the crisp, corporate character of the overall graphic style. Even the visual jokes are subtle and almost detached—as in the case of the Richman & Associates logo, which uses a leaf as a symbol of the firm's commitment to quality landscape architecture. And while some firms let their designers go slightly overboard in the sort of visual "riffing" that led to the creation of the whimsical marks for Catwalk Digital, the Boneyard, and Digital Sherpas, others are reluctant to do so—consider, for example, the extremely restrained logo Michael Westcott created for his new market-strategy firm, one that seems to run counter to his decision to call the company "Firebrand." Aren't a lot of these logos a bit stuffy?* one *is ready to ask. Of course not—to be effective, commercial design must, after all, be visually and conceptually targeted to appeal to a particular audience, which is exactly what these logos do so well.*

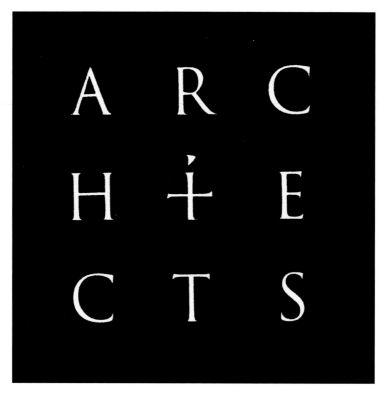

Design Firm:
Communications Arts Co., Jackson, MS
Art Director/Designer:
Hilda Strauss Owen

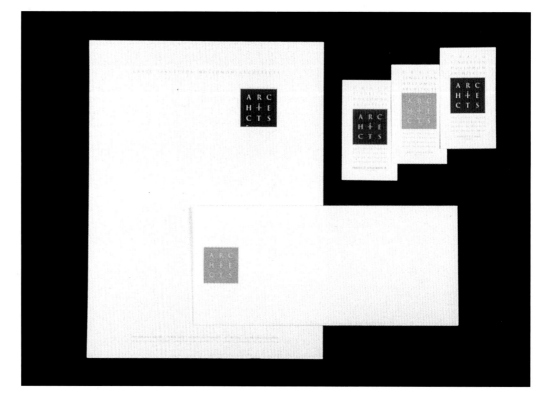

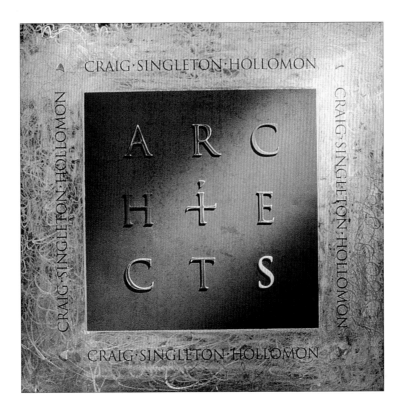

With a name change and the retirement of its senior partner, this 20-year-old Mississippi firm needed a fresh visual identity. The new logo reflects the diversity of the firm's work by combining classical typography with bright primary colors and a playful twist on the spelling of "Architects." Without changing the initial concept, the designer explored various typestyles and different ways of arranging the nine letter-forms. She created the logo, which now adorns the firm's stationery and presentation documents, using Aldus FreeHand.

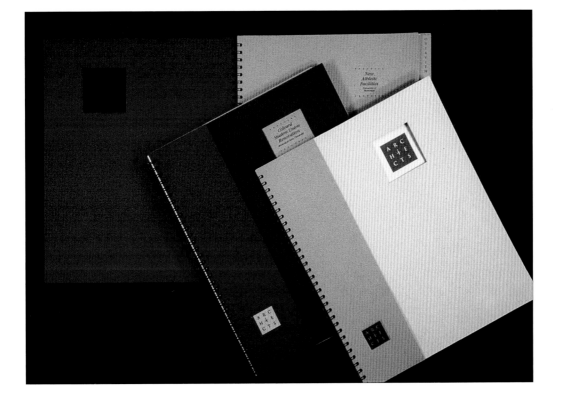

CRAIG SINGLETON HOLLOMON ARCHITECTS

TOM RICHMAN AND ASSOCIATES

The new logo for Richman & Associates reflects its expansion into the field of urban design. The designers took an excerpt from a scanned planning blueprint for the logo's centerpiece. Rendering the excerpt in the shape of a leaf and coloring it a deep forest green suggest the firm's continued commitment to landscape architecture. Adobe Illustrator was used to create the logo; it was then offset-printed onto company stationery.

Design Firm:
Artefact Design,
Palo Alto, CA

De Jong devised this logo for "the hardest client ever"— her father's architectural firm. In making a group of sketch-like drawings the centerpiece of the mark, she conveys a sense of the creative process at the heart of architectural design. She used Adobe Photoshop and QuarkXPress to assemble the logo; it was then offset-printed onto the client's stationery.

Harmen de Jong
ARCHITECTENBUREAU

Design Firm:
Irma de Jong
Graphic Design,
Charlotte, NC
Designer:
Irma de Jong

CYNTHIA GENTRY, WRITER

On setting up her own marketing and public relations copywriting firm, Cynthia Gentry sought a logo reflective of both her witty personality and her creative approach to problem-solving. The designers crafted a distinctive mark that gives potential clients a good sense of Gentry's personal and professional qualities. The pen-and-ink illustration was prepared in QuarkXPress for reproduction on Gentry's stationery and business cards.

Design Firm:
Studio A,
San Francisco, CA
Art Director/Designer:
Jana Anderson
Illustrator:
Sally French

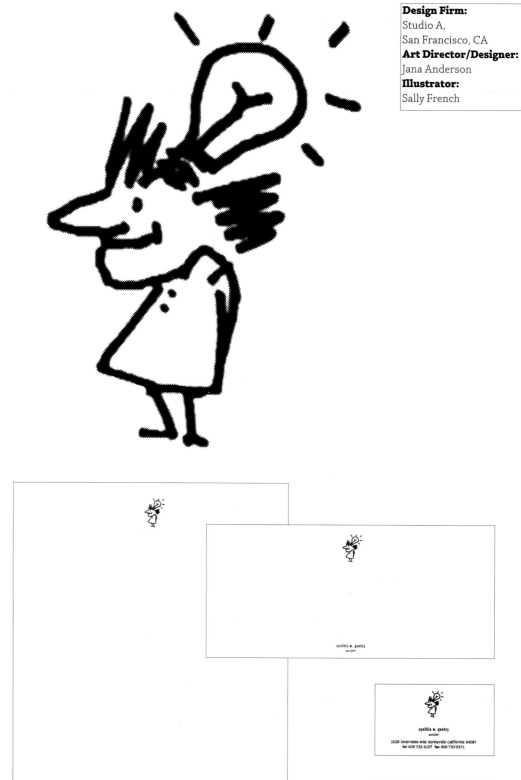

Design Firm:
Nancy Davis Design
and Illustration,
Santa Monica, CA
Designer:
Nancy Davis

Davis met four requirements in creating this logo: that it be "original, fun, reflective of the writing process, and inexpensive to reproduce." By stylizing the handwritten initials *MM* in one color, she gave the mark a distinctly personal touch, helping her client distinguish herself from her many competitors in the copywriting business. Davis used Aldus FreeHand and Wacom Tablet to produce the final design.

Sunu's logo ties together this production studio's name and its craft—the initials *BB* are rendered as a pair of backward eighth notes, with the jagged line between them representing the readout on an analog sound meter. Other, similar designs were rejected, including one setting the initials inside a block capital *M*—too similar to MTV's logo, she felt. Sunu created the basic image in Adobe Photoshop, then cleaned it up with Adobe Illustrator before exporting it to QuarkXPress for layout work.

Design Firm:
Sunu Squared Design,
Los Angeles, CA
**Art Director/Designer/
Illustrator:**
Judy K. Sunu

Design Firm:
Brinkley Design,
Charlotte, NC
Designer:
Leigh Brinkley

In this mark for Wyndham Music, the initials *WM* are depicted as stylized piano keys, alluding to the company's specialty: providing original music for films and commercials. Not that this idea was easy to come up with—the client went through three months' worth of design concepts before agreeing to this one. Adobe Illustrator and QuarkXPress were used to prepare the logo for reproduction on company stationery and other materials.

WYNDHAM MUSIC

Mexican folk art inspired this logo for a new recording studio opened by Joe Perry of the rock group Aerosmith. Perry selected this design from several presented to him; all were executed in one color for ease of reproduction and graphic power, and all shared an informal feel and a reliance on skeleton imagery. The designer created the logo with marker and ink, then scanned it and reworked it using Adobe Illustrator for reproduction on a variety of items, including studio stationery and guitar picks.

Design Firm:
Sonalysts Studio,
Waterford, CT
**Art Director/Designer/
Illustrator:**
Rena DeBortoli

In-Store Marketing

Muzak Special Products

Business TV

This set of icons is part of an image redefinition effort for Muzak, a music and business subscriber service. Each mark literally reflects the name of a service offered by the company, a task that the designer clearly had some fun with—witness the "Business TV" and "Business Music" icons. The bold black-and-white silhouettes ensure that the marks are easily usable in a variety of contexts, including interactive presentations, printed brochures, and T-shirts. The designer created them using Macromedia FreeHand and Adobe Illustrator.

MUZAK

Marketing Services

Direct Broadcast Satellite

SCA: Radio Transmissions

Broadcast Data

Business Music

Sound Systems

National Accounts

ZTV: Entertainment Television

Broadcast Information

Design Firm:
David Lemley Design,
Seattle, WA
Designer:
David Lemley

Tones: Tape Service

Audio Marketing

Visual Merchandising

By rendering the initials *IM* as a human figure casting a shadow, Wu-Ki turned this logo into a symbol of both her client's specialty—image creation and enhancement for small business owners—and the personal attention which the firm offers its customers. She created the mark using Aldus FreeHand.

Design Firm:
AWK Design,
Waipahu, HI
Designer:
Angela Wu-Ki

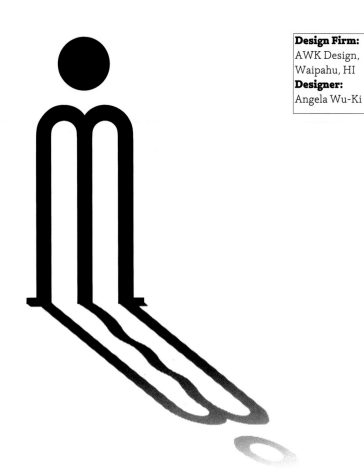

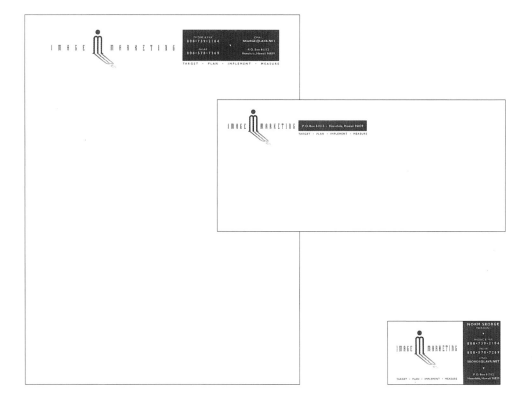

Design Firm:
Brinkley Design,
Charlotte, NC
Art Director:
Leigh Brinkley
Designers:
Leigh Brinkley,
Corinne Geney
Illustrator:
Corinne Geney

This playful mark, the figure of a cat shaped like a letter *W*, is a visual pun on Catwalk Digital, a company specializing in communications and post-production services. The clean, crisp rendering of the image conveys a sense of the client's professionalism. The designers used Adobe Illustrator and QuarkXPress to create the logo, which was offset-printed onto company letterhead and other materials.

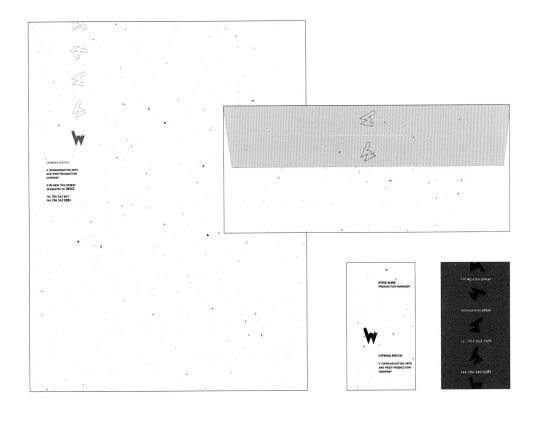

This memorable logo for Firebrand highlights the brand development capabilities of this new marketing-strategy firm. The designer emphasized the letter *B* (which stands for both "brand" and "breakthrough") by encircling it—a reference to the widely recognized symbol for copyrighted material—and rendering it in fiery red. He used Aldus FreeHand to assemble the logo which was used on company stationery and various other printed items.

F I R E Ⓑ R A N D

Design Firm:
Firebrand,
Providence, RI
Art Director/Designer:
Michael Westcott

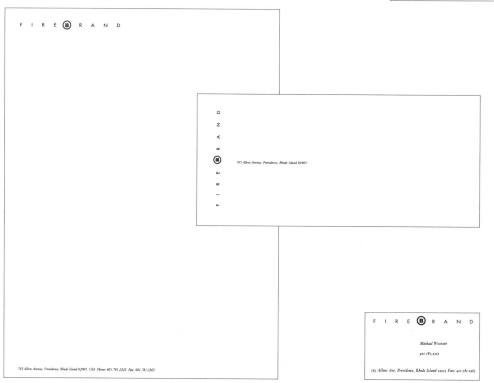

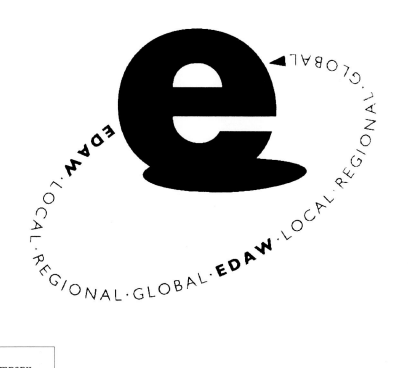

This international landscape architecture and planning firm, which has been in existence for over half a century, wanted a "secondary logo" for various advertising, informational, and business materials, including promotional stickers and brochures to commemorate Earth Day. The designers' simple, straightforward approach highlights EDAW's worldwide presence: the inscription "local, regional, global" surrounds a central *e*, shorthand for the firm's name and also a symbol of the globe. Adobe Illustrator was used to create the logo.

Design Firm:
McGraw & Company,
San Francisco, CA
Creative Director:
Lyn Hogan
Art Director/Designer:
Martha McGraw

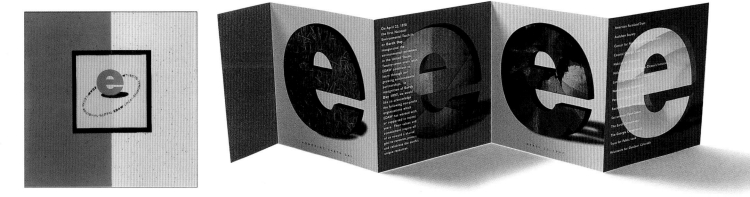

This design provides a visual representation of creativity—a quality this Silicon Valley investment firm looks for in choosing which start-up companies to fund. The arrangement of symbols in electrical schematic drawings is both painterly and playful, with the symbols themselves alluding to the emerging technology companies in which ITV invests. Guidice used Adobe Illustrator to create the logo.

INFORMATION TECHNOLOGY VENTURES

Design Firm:
Energy Energy Design, Campbell, CA
Art Director/Designer:
Leslie Guidice

This logo for a corporate communications services company reflects its move into new media technology. EEI's previous logo had been largely typographic—suggestive of its strong editorial tradition—while this one is primarily visual. Stylized "longitude and latitude" lines convey a sense of modernity and dynamism. The designer worked in Macromedia FreeHand and CorelDraw.

EEI COMMUNICATIONS™

Design Firm:
EEI Communications,
Alexandria, VA
Art Director/Designer:
Davie E. Smith

In the rapidly growing field of Internet consulting, Digital Sherpas management sought a unique company identity. Working on a budget they describe as "very, very small," the designers devised this simple, attractive logo that presents the company as "a guide to the digital realm" and (perhaps more importantly) exudes the sort of goofy hipness that permeates Net culture. The art was created in QuarkXPress, with finishing touches added in Adobe Illustrator.

Design Firm:
WONGDOODY,
Seattle, WA
**Art Directors/
Designers:**
Tracy Wong,
Michael Boychuk
Illustrator:
Michael Boychuk

Design Firm:
Henderson Tyner Art Co.,
Winston-Salem, NC
Art Director/Designer:
Hayes Henderson

Who knew a company specializing in 401K pension consulting could have such a cool logo? Henderson created a strong, serious identity for a new executive life-insurance program while relatively "un-corporate." An updated '50s-style illustration is the central image, rendered in straight black-and-white to ensure ease of reproduction and boldness of look. The figure stands erect and looks off into the distance, suggesting AON's focus on sober, long-term planning, while the arrow that swirls from bottom to top alludes to the company's commitment to creative pension solutions. Henderson used Aldus FreeHand and Adobe Streamline to design the mark.

AON CONSULTING

Although Gales Creek's logo was outdated and, in Galick's words, "told too little about them," the company was initially reluctant to commission a new one. But as part of an effort to recruit customers, particularly non profit organizations and entertainment providers, they hired Galick to come up with a replacement mark. A number of design concepts were presented, some conveying a sense of the firm's committment to customer service, others highlighting the breadth of coverage it offers. In the end, Gales Creek chose a logo relating only indirectly to the insurance industry. The design solution was to "spell out" the firm's name in shorthand by combining a letter *g* with a stylized rendering of a creek. The original logo was created in Aldus Freehand, the final artwork in Adobe Illustrator.

Design Firm:
Jeanne E. Galick
Graphic Design,
Portland, OR
Designer:
Jeanne E. Galick

Design Firm:
Timmerman Design,
Phoenix, AZ
Art Director:
Diana Moore
Timmerman
Designer:
John Roman Brown

DPA, which specializes in large civic projects and skyscrapers, wanted to replace its existing mark with a more sophisticated logo, one that conveyed a sense of its professionalism and creative approach to architecture. Initial concepts that relied on typography or illustration were rejected in favor of this relatively spare, dramatically proportioned design. Adobe Illustrator and QuarkXPress were used to create the logo and prepare it for reproduction on the firm's stationery set.

This punny mark presents Slice, a new company specializing in post-production editing of TV commercials, as committed to communicating its clients' messages clearly and directly. In addition, the "sliced" logotype refers to the editing practices of an earlier time, when film was physically cut and spliced together. When the firm chose its name, Pennington notes, the basic design concept followed quickly. He created the final mark in QuarkXPress.

slice

Oh, shit.

For years I've been cutting spots at Straight Cut for the likes of David Wild, Peter Nydrle, Fallon McElligott, Hal Riney & Partners, and others. Now I'm about to go out on my own. I don't even have baseball caps yet. Oh, shit. Call and tell me it's gonna be o.k. 206.667.8703. Slice Editorial, Johnna Turiano, Proprietor.

Design Firm:
Creative Partners,
Seattle, WA
Art Director/Designer:
Chuck Pennington

slice

SLICE EDITORIAL

1932 FIRST AVENUE, SUITE 203

SEATTLE, WASHINGTON 98101

slice

JOHNNA TURIANO

SLICE EDITORIAL

1932 FIRST AVENUE, SUITE 203

SEATTLE, WASHINGTON 98101

206.441.9092 F: 206.441.9270

slice

SLICE EDITORIAL

1932 FIRST AVENUE, SUITE 203

SEATTLE, WASHINGTON 98101

206.441.9092 F: 206.441.9270

Consumer Services

It's easy to forget that we all deal with consumer-service providers on a regular basis—unlike a trip to the store, these encounters don't always leave us with a specific product, and many are so routine that we simply overlook them. There are exceptions, of course—it's not every day that one drops by Mad Cow Farms for a horseback-riding lesson, of course, or hires a team of Blackfoots to build a house. But, in the main, what these companies do can too often seem mundane to the average consumer—a circumstance designers must take into account. Getting these businesses noticed now is all the more important because many of them are quite small, and thus dependent on a constant flow of new customers. The designers whose work is featured here are clearly aware of these challenges, and have put a panoply of familiar "attention-getting" visual and conceptual strategies to work, while still managing, in most cases, to give their designs an informal feel that lets prospective customers know they can expect personal-touch service. The punny humor of the mark created by Randall Smith for Dr. Rand Bennett, the child-like silliness of the one the Simantel Group did for Mad Cow Farms, the straightforward "I'm Jeff and I'll be cutting your hair" assertion concocted by Jeff Fisher for Portland's Maul Salon—winning solutions, each of them, that successfully captured customer attention.

Design Firm:
Randall Smith Associates, Salt Lake City, UT
Designer:
Randall Smith

DR. RAND BENNETT & TEAM
Specialist in Orthodontics

A crooked picket fence and a straightened one present this orthodontist's potential patients with an inspired "before and after" testimonial to the quality of his work. The design avoids showing sets of teeth, which some might find off-putting—a fact that Dr. Bennett himself pointed out. Additionally, the warmly rendered fences convey a sense of comfort and familiarity, thus helping to offset the nervousness many associate with visits to the tooth doctor. In creating this logo, Smith began with a photo of a fence, which he manipulated in Adobe Photoshop until it was ready to be laid out in QuarkXPress.

DR. RAND BENNETT & TEAM
Orthodontics

1400 S. FOOTHILL DR. #240
SALT LAKE CITY, UTAH 84108
TELEPHONE 801-581-1234
FAX 801-581-1626

1400 S. FOOTHILL DR. #240, SALT LAKE CITY, UTAH 84108

DR. RAND BENNETT & TEAM
Specialist in Orthodontics

DR. RAND BENNETT & TEAM
Specialist in Orthodontics

HEATHER BARNES
Orthodontic Clinician

DR. RAND BENNETT

The designer's approach to creating a logo for this family dentist was straightforward—render her name in a distinctive face, then add graphic detailing that suggests her line of work, along with a splash of color for emphasis. This design replaced an existing logotype that consisted of the doctor's name spelled out in calligraphy. Center used CorelDraw for both illustration and layout.

Design Firm:
Centerdesign,
New York, NY
Art Director/Designer:
Mildred Center

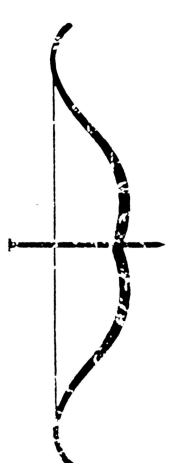

Sockwell creates a highly distinctive identity with this simple mark, which does not refer to his client's line of business, but nonetheless ensures that potential customers will remember Blackfoot Construction. By using a bow motif, Sockwell establishes a strongly visual associative link between the firm and the Native American background of its employees. Response to the logo has been positive, he notes, particularly because it's so different from those of its competitors. He used Adobe Illustrator, an office photocopier, and Adobe Photoshop to create the mark.

Design Firm:
Felix Sockwell Creative,
San Francisco, CA
Art Director/Designer:
Felix Sockwell

Sometimes the simpler the design concept, the better. In this case, Fuller Plumbing wanted a mark that would identify its line of business in no uncertain terms—a task perfectly fulfilled by this logo, which is formed by a starkly silhouetted figure that is at once a pipe and a pipe wrench. Eisenberg created the design in Adobe Illustrator.

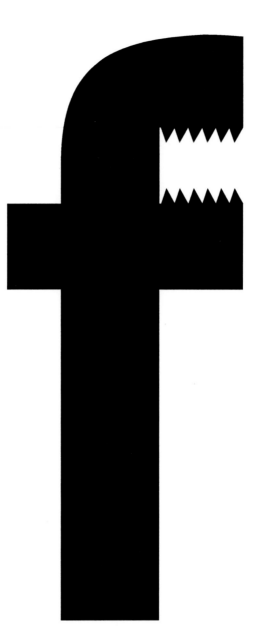

Design Firm:
Eisenberg and Associates, Dallas, TX
Art Director:
Arthur Eisenberg
Designer:
Jason Barnes

Zielinski Associates created this logo for Complete Connection's Home Team, a a network of self-employed home-repair experts. By depicting the members of the Home Team marching in unison, each carrying the tools of his trade, the designers suggest their simultaneous independence and interdependence, while also alluding directly to the services they provide. The logo was rendered as a simple silhouette to ensure that it would be visually bold and also reproduce well in the Complete Connection's 1-color introductory brochures. The '20s-style illustrations, meanwhile, intended to provide a chuckle or two, were created in Adobe Illustrator.

Design Firm:
Zielinski Design
Associates,
Dallas, TX
Art Director:
Tom Zielinski
Designer/Illustrator:
Christine Grotheim

Dolls Salon came to Kraus with a familiar problem: although it had been operating for years, the salon had no logo, and its name was rendered in a number of different ways on business cards, letterheads, and signage. In devising this mark, instead of targeting a specific audience, Kraus conveyed the idea that the salon's stylists are ready to serve "anyone with hair"— hair of all types, as indicated by the variety of styles depicted. The logo was created in Adobe Illustrator.

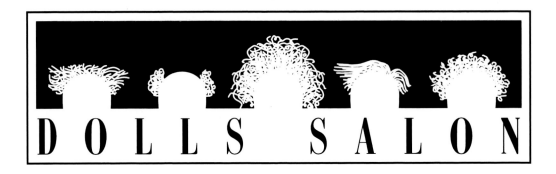

Design Firm:
KWGC, Dallas, TX
Art Director/Designer:
John Kraus

Jeff maul

The positive response generated by this design for a Portland hair salon is a reflection of its elegance and straightforward simplicity. Fisher frankly states that the design also represented an obvious solution to the task at hand—this was the one and only logo concept he submitted to the client. In exchange for creating it, which he did with Macromedia FreeHand, he received ten free haircuts!

Design Firm:
Jeff Fisher Design,
Portland, OR
Art Director/Designer/
Illustrator:
Jeff Fisher